D1163603

Cabins of Minnesota

Cabins of

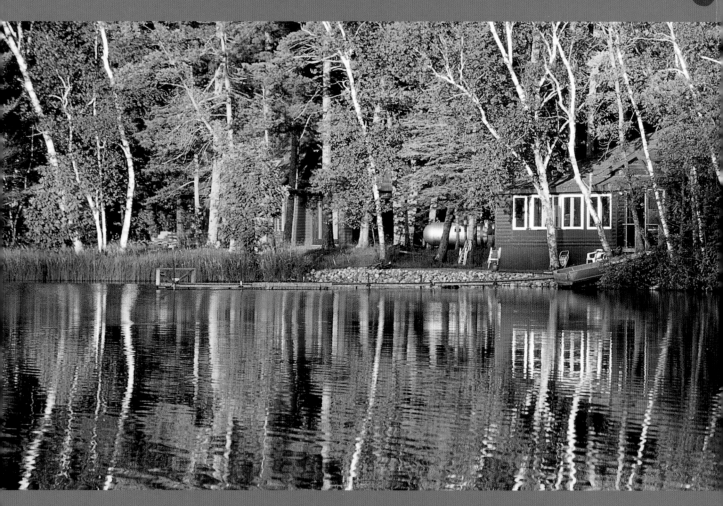

minnesota byways

Minnesota

PHOTOGRAPHY BY DOUG OHMAN

TEXT BY BILL HOLM

MINNESOTA HISTORICAL SOCIETY PRESS

I dedicate, with thanks and praise, this cabin essay to my congregation of cabinologists:

Hallgrímur Gunnarsson, Valgeir Þórvaldsson, Þórhallur Þórvaldsson, Wincie Jóhansdottir.

They have repaired me, calmed me, fed me, and instructed me on how to live a right life

in an old cabin next to a large ocean.

BILL HOLM *Minneota, Minnesota*

Publication of this book was supported in part by the Elmer L. and Eleanor J. Andersen Publications Endowment Fund of the Minnesota Historical Society.

© 2007 by the Minnesota Historical Society Press. Text © 2007 by Bill Holm. Photographs (except on pages 95 and 128, top) © by Doug Ohman. All rights reserved. No part of this book may be used or reproduced in any manner whatsoever without written permission except in the case of brief quotations embodied in critical articles and reviews. For information, write to the Minnesota Historical Society Press, 345 Kellogg Blvd. W., St. Paul, MN 55102-1906.

www.mhspress.org

The Minnesota Historical Society Press is a member of the Association of American University Presses.

Manufactured in China by Pettit Network, Inc., Afton, Minnesota

Book and jacket design by Cathy Spengler Design

10 9 8 7 6 5 4 3 2 1

∞ This book is printed on a coated paper manufactured on an acid-free base to ensure a long life.

Photograph, pages 2–3: Lake Emma, Hubbard County; page 95: Bert L. Brown/MHS Collections; and page 128, top: Throstur Valgeirsson.

International Standard Book Numbers
 ISBN-13: 978-0-87351-549-8 (cloth)
 ISBN-10: 0-87351-549-8 (cloth)

Library of Congress Cataloging-in-Publication Data

Ohman, Doug.
Cabins of Minnesota / photography by Doug Ohman ; text by Bill Holm.
 p. cm.
ISBN-13: 978-0-87351-549-8 (cloth : alk. paper)
ISBN-10: 0-87351-549-8 (cloth : alk. paper)
 1. Log cabins—Minnesota—Pictorial works.
 I. Holm, Bill, 1943–
 II. Title.

NA8470.O46 2007
728.7'309776—dc22

 2006035317

Cabins of Minnesota

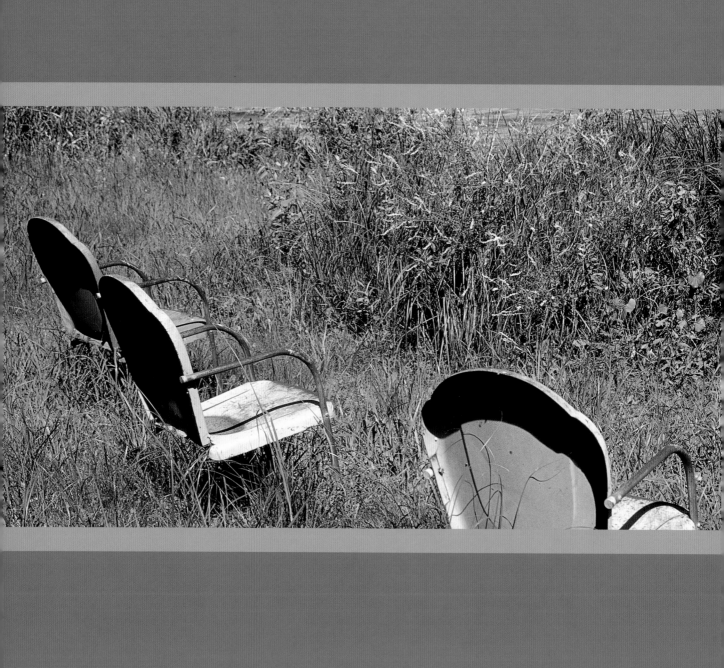

1

On a cabin retreat,

pleasure overcomes duty

for a little while.

*O*nce asked a freshman English class a question—something to think on—for which no research, no facts, no "right" answer could possibly be available to them. This question flummoxed them: Write a description of your own life in, say, twenty years, when you are forty. What are you doing? Where do you live? Are you married with children—or not? What is your joy? The answers flummoxed *me*. They were almost unanimous in being married, with children, mostly gone from their small towns and farms in rural Minnesota to the Cities (or maybe California or Colorado or Arizona, some scenic warmer place). All were employed—at high salaries and good benefits—for some anonymous com-

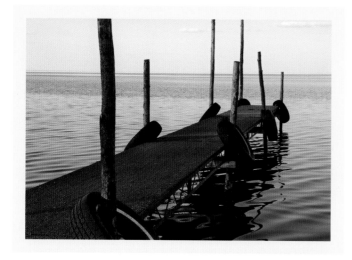

pany, generally at office work (lots of business and computer majors). They knew which brand of car they would drive and in what trendy suburb they would own their multi-level villas. They were almost unanimous, too, in the assumption that their lives would be a little boring, the job mostly ho-hum, the marriage routine after so long (they didn't foresee divorce), the children expensive and argumentative.

Where was the *real* life, the joy? Always at the lake, or deep in the woods, in a log cabin, with fish and birds, maybe a bear or two, northern lights, loons hooting, wind sighing in the pines, the smell of meat on a grill, a cold beer, quiet, privacy, beauty—but only for a few days at a time, then back to the freeway commute, the com-

8

PREVIOUS PAGES Lake Traverse, Traverse County

ABOVE Wigwam Bay, Mille Lacs, Mille Lacs County

puter screen, the mall trip, the evening news on TV, the sirens in the night. I don't dare give this assignment again. I was depressed for a month afterwards.

But maybe I should have thought twice. The students were only being good Americans, joining a long tradition that had clearly laid its hook into their psyches whether they knew its ancestry or not. These days, I just teach Henry Thoreau, letting *him* ask the uncomfortable questions, to trouble the practical souls all by himself with his cast-bronze prose.

Walden is a curious "great" book for Americans to have taken close to their souls; looked at from one angle, it excoriates every aspect of ordinary life in an industrialized, market capitalist country. Do not get married or procreate. Do not get a job. Do not acquire goods, gadgets, or real estate. Eat, drink, and clothe yourself spar-

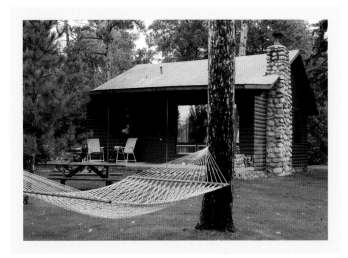

ingly, but above all, thriftily. Learn several languages; Greek is best and will do you the most good. Do not fear physical work, but don't expect to be paid for it. Contradict all authorities, in politics, government, religion, education—for *your* own good. Ignore all media; Thoreau specified newspapers, but had they been invented, he'd have included radio, TV, and the Internet.

What is your joy?

He thought the post office delivered no mail worth opening. Stay out of all stores; cook your own dinner from whatever you have at hand—a dinner of purslane and salt, friends? Stay mostly silent; conversation is either idle chitchat or gossip. Think long thoughts in solitude for many hours a day,

ABOVE Cry of the Loon Resort (1963), Lake Kabekona, Hubbard County

9

or days on end while watching a bird, a mouse, a snake, leaves moving in the wind, snow falling, water sloshing. Practice your flute regularly. Live cheap.

So what is the interior metaphor of *Walden* that so haunted my students? The lake (or the river, sea, or pond), the rustic cabin (escape from the stress of getting and spending), the pleasures of fishing, daydreaming, sunset watching, and star counting, the leisure to take stock of one's life without the surround-sound noise of the new wired century. In a cabin retreat, pleasure overcomes duty for a little while. Nature overcomes the clanking of machinery, the purring of computers, the bells and whistles that summon us to do the bidding of our masters/employers.

> *The morning, which is the most memorable season of the day, is the awakening hour.*
>
> Henry David Thoreau, Walden

The morning, which is the most memorable season of the day, is the awakening hour. . . . For an hour, at least, some part of us awakes which slumbers all the rest of the day and night. Little is to be expected of that day, if it can be called a day, to which we are not awakened by our Genius, but by the mechanical nudgings of some servitor.

Henry, like my students, indeed like all of us, was no lover of alarm clocks that summon us from the world of dreams. He wished to be awakened "from within, accompanied by the undulations of celestial music, instead of factory bells." I recently held my nose, put my principles and good sense in abeyance, and bought my first cell phone. The eager clerk tried to show me how to set the mobile alarm clock. "Don't you dare," I hissed. What might Thoreau have thought of a tiny telephone able to interrupt his "Genius" on command? We must all learn from Henry.

Here, embedded in *Walden,* is the credo of the cabin, of American idealism,

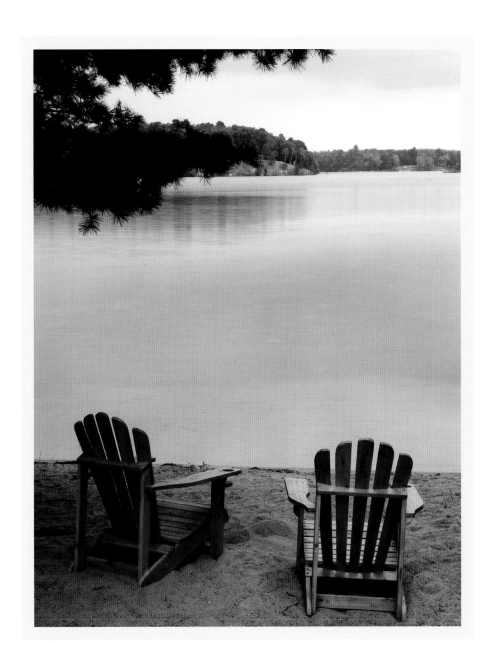

ABOVE Lower Whitefish Lake, Crow Wing County

of the "meaning of life." Even Americans who have never read Thoreau hear the echo of this passage in their inner ear or their conscience. Here is Henry:

I went to the woods because I wished to live deliberately, to front only the essential facts of life, and see if I could not learn what it had to teach, and not, when I came to die, discover that I had not lived. I did not wish to live what was not life, living is so dear; nor did I wish to practise resignation, unless it was quite necessary. I wanted to live deep and suck out all the marrow of life, to live so sturdily and Spartan-like as to put to rout all that was not life, to cut a broad swath and shave close, to drive life into a corner, and reduce it to its lowest terms, and, if it proved to be mean, why then to get the whole and genuine meanness of it, and publish its meanness to the world; of, if it were sublime, to know it by experience, and be able to give a true account of it in my next excursion. For most

men, it appears to me, are in a strange uncertainty about it, whether it is of the devil or of God, and have somewhat hastily concluded that it is the chief end of man here to "glorify God and enjoy him forever."

Still we live meanly, like ants; though the fable tells us that we were long ago changed into men; like pygmies we fight with cranes; it is error upon error, and clout upon clout, and our best virtue has for its occasion a superfluous and evitable wretchedness. Our life is frittered away by detail. An honest man has hardly need to count more than his ten fingers, or in extreme cases he may add his ten toes, and lump the rest. Simplicity, simplicity, simplicity! I say, let your affairs be as two or three, and not a hundred or a thousand; instead of a million count half a dozen, and keep your accounts on your thumb-nail.

ABOVE Hand carved handle, "Ober's House," Mallard Island, Rainy Lake, Koochiching County

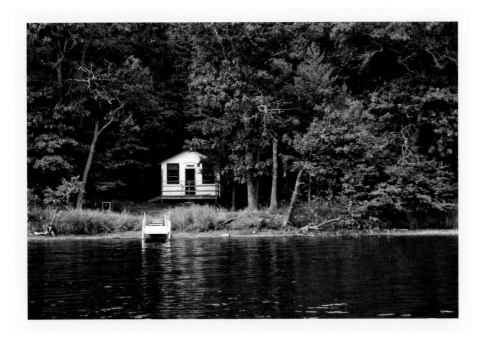

Whenever in my childhood, in imitation of Thoreau, I would proclaim my intention to simplify by practicing poetry or maybe composing small fugues—for a living—my farmer father would say, "Talk is cheap but it takes money to buy whiskey." He was a wise man—wiser than I understood at the time.

Thoreau is, with his metaphor of ants and cranes, being playful, always a paradoxical fellow. When he decides to try his experiment in the woods, he surveys the countryside around Concord "in Imagination," offering hypo-thetical prices for farms. "This experience entitled me to be regarded as a sort of real-estate broker by my friends." "Thoreau's Super Deals on Hot Lakefront Second Homes," might read the *Shopper* ad. But Henry, never falsely modest, has more in mind than a golf or fishing retreat. "Wherever I sat, there I might live and the landscape radiated from me accordingly.

ABOVE Cabin on the grounds of Bay Lake Camp (circa 1930), Bay Lake, Crow Wing County

What is a house but a *sedes,* a seat?—better if a country seat." Wherever either you or Thoreau are is earth's center, or the cosmos's center, to up the ante, since all points are now equidistant from your survey. This is quite a real estate deal he has in mind.

The facts are less cosmic. Thoreau's mentor Emerson had bought most of the land around Walden Pond to save it from the woodchopper's axe. He made a deal with young Thoreau: free rent for clearing some scrub and reforesting with pines. The next year, 1845, Thoreau began building his cabin on Emerson's land. Though not a trained or experienced carpenter, he thought to accomplish two goals in building it himself: first, so that "architectural beauty . . . has gradually grown from within outward, out of the necessities and character of

Thoreau kept an exact ledger of his expenses . . . noted down to a penny for chalk and a dime for a latch.

the indweller, who is the only builder," and second, to save money. Ever the penny-squeezing Yankee, Thoreau kept an exact ledger of his expenses: his 10' by 15', 8-foot-high cabin cost $28.12½, noted down to a penny for chalk and a dime for a latch.

Thoreau was a tiny bit of a hypocrite; or perhaps better, a dissembler at Walden. He claimed, as most of us do, to retreat to his cabin in the woods for solitude, privacy, meditation. In fact, he was two miles from town and made frequent trips to Emerson's house for Mrs. Emerson's pies—purslane is all right, but no one ever died from a little dessert. He seems to have been a sociable man, even in his retreat. His neighbor, Joseph Hosmer, was a dinner guest at Henry's cabin in September 1845 and left a whimsical description of his evening. "His hospitality and manner of entertainment were unique, and peculiar to the time and place." The bill of fare "included roasted horn pout, corn, beans, bread, salt etc. Our viands were nature's own, 'sparkling and bright.' I gave the bill of fare in English and Henry ren-

dered it in French, Latin and Greek." He roasted the fish over hot stones in wet paper and seasoned it with salt. Hosmer reports it was delicious. Henry entertained his guest with tales of cabin life: of serenading his house mouse with his flute, of saving his bean patch from a rapacious woodchuck. That tale made its way into the text of *Walden.* In addition to writing sterling prose, Thoreau seems to have been a clever cook and a good host. Aren't those cabin skills, too?

Had he lived one hundred and sixty-two more years until 2007, he would have had more houseguests than Joseph Hosmer: 600,000 a year, to be exact. Walden Pond is now a state park, with gift shop, bookstore, a five-dollar admission charge fed into an automatic ticketing machine, and an exact replica of Thoreau's cabin. Emerson sold the original to his gardener, who used it for grain storage and eventually dismantled it. Thoreau himself used recycled lumber to build the original: the second recycling would undoubtedly

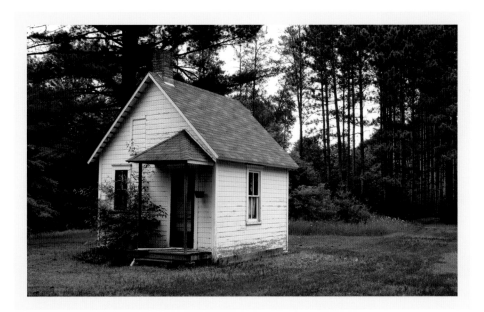

ABOVE Summer cottage, Stanchfield Township, Isanti County

have pleased him. Waste not good boards, or the straightenable nails pounded into them. The universe might have use for them.

We remember Walden Pond, of course, for neither architecture nor for natural beauty but because an eccentric writer made his experience there into one of the great books of world literature. We go there, as to Stratford to honor Shakespeare or to Gough Square where Johnson made his Dictionary, because it is a holy place for civilization. The human race made a little progress there, for a change.

Waste not good boards, or the straightenable nails pounded into them.

In the early 1970s a cousin of mine, Charles Josephson, had taken a job as an editor for a publisher in Boston and bought a big old house in Concord, an hour by train from his work. I was teaching in Virginia and decided to go north for a small family reunion at Thanksgiving. We had a fine dinner at his table, a good deal better than Hosmer's, and a good deal of whiskey and red wine Hosmer wouldn't have enjoyed. Since this was my first trip to Concord, I felt like a medieval pilgrim come to make oblation to the ghosts of Emerson, Thoreau, Alcott, Hawthorne. Walt Whitman had even visited Concord. The after-dinner talk was full of literature, probably misquotations of American classics. Snow began to fall over Concord, big, wet, slow flakes, Robert Frost snow. At about midnight, either Josephson or I proposed a circumambulation of Walden Pond, a few miles from his house. Ken, his nine- or ten-year-old son perked up. "I want to go with Dad and Uncle Bill." His mother sensibly discouraged the whole scheme, but we were not about to be put off our plan for a snowy mid-

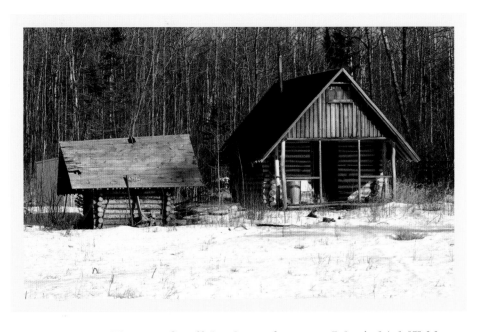

night homage to Thoreau. So off the three of us went. I don't think Walden was fenced in 1971 or 1972, but if it was, we climbed over it. There was a walking path around the small lake. The slow snow continued. We two slightly tipsy fellows held Ken by a hand apiece between us while continuing a stream of misquotation: "Beware of all enterprises that require new clothes . . ." "For many years I was self-appointed inspector of snow storms," and when we sighted the still-present railroad tracks running to Boston, "We do not ride on the railroad; it rides on us." We saw not a soul, nor Henry's ghost, only snow and bare trees. We returned after an hour to cocoa, cognac, and bed. Ken, now in his forties, has never forgotten that night. That's the sort of night one retreats to cabins to enjoy. Try it yourself.

ABOVE Hunting cabin, Koochiching County

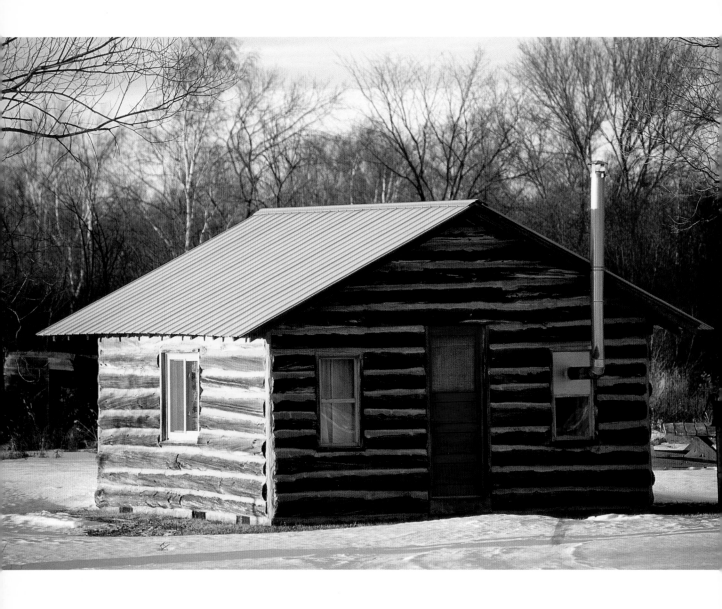

ABOVE Log cabin, Waskish Township, Beltrami County

BELOW Log cabin in the village of Angle Inlet, Lake of the Woods County. The area known as the Northwest Angle is the only part of the United States, outside of Alaska, that is north of the 49th parallel.

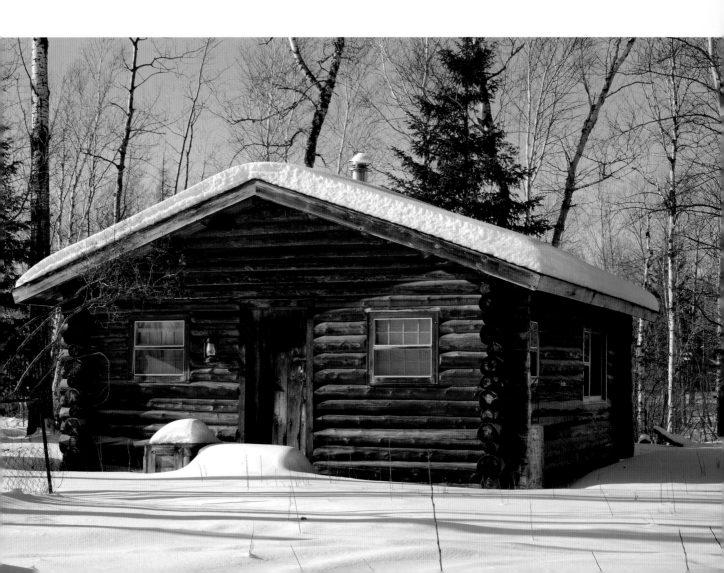

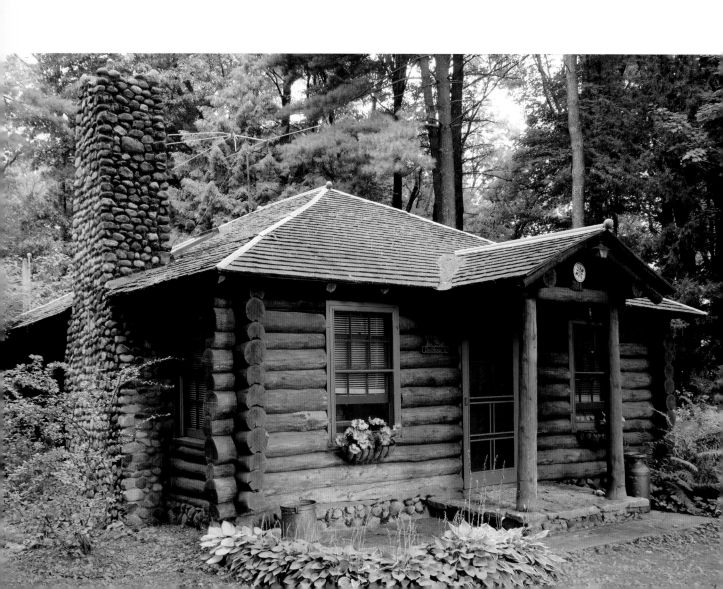

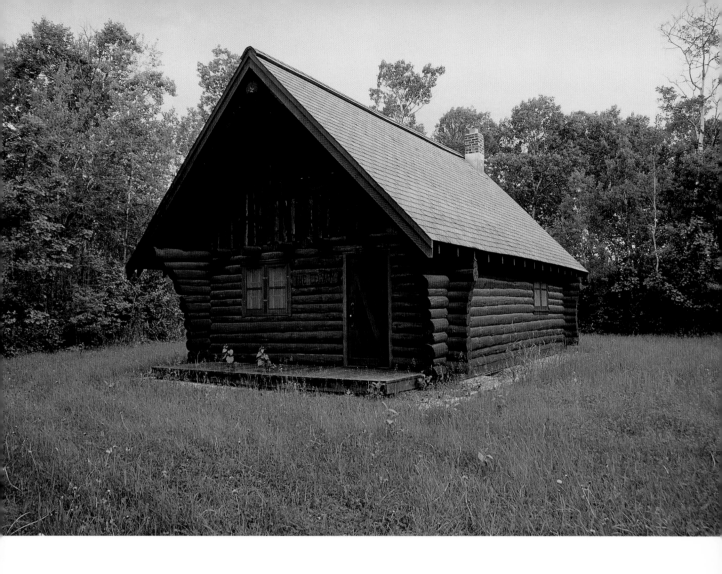

ABOVE "The Legacy" cabin was built by Philip Dyrud as a small getaway retreat for his family.
The cabin sits in a small clearing about a half mile from the nearest paved road. Pennington County.

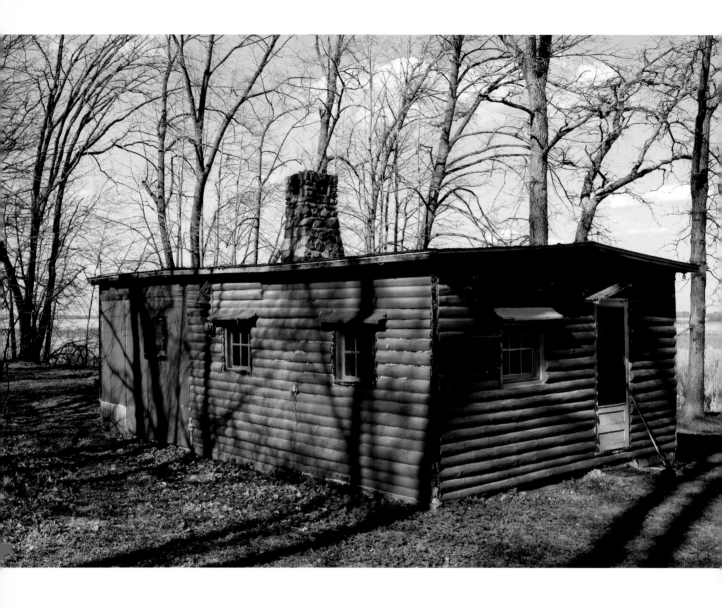

ABOVE Rustic cabin on Big Rice Lake, Cass County

BELOW Cabin on Detroit Lake, Becker County

NEXT PAGES Lakeshore cabin at Breezy Point Resort on Lake Superior, Lake County. The resort was opened in the mid-1930s just off the North Shore Scenic Drive, south of Two Harbors.

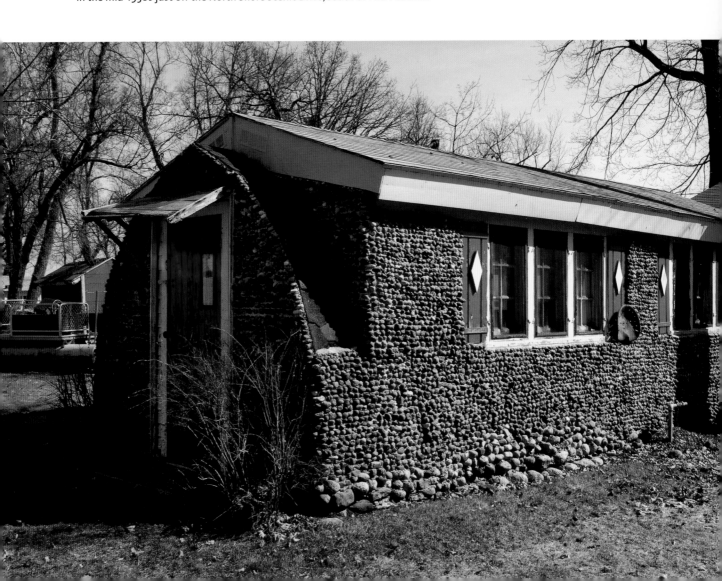

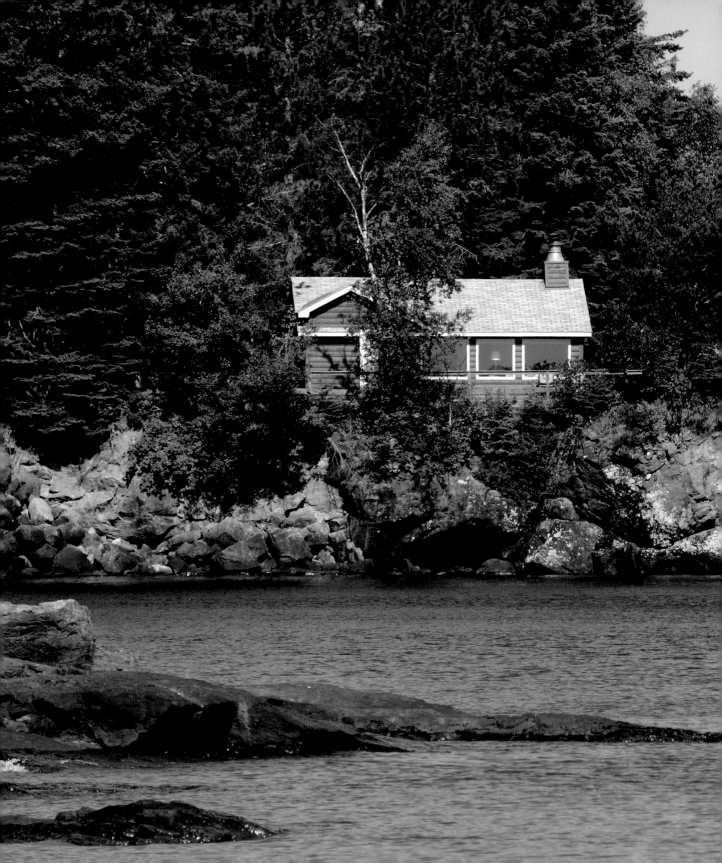

ABOVE Morning calm at the Cry of the Loon Resort, Lake Kabekona, Hubbard County. Cry of the Loon is one of the oldest resorts on Lake Kabekona. Over the years the resort has gone through several owners and name changes. In the 1920s it was known as Pine Ridge Resort. By the late 1930s it was called Leaf Lodge, after its owners, the Leaf brothers. Idle Days was its name in the 1950s, and by 1963, it had received its current name, Cry of the Loon. The owners, Bill and Nancy Booth, purchased the resort in 1973 and continue to entertain guests throughout the year.

BELOW Boathouse cabin overlooking the Mississippi River, Winona County. Cabins can be found all along the Mississippi River in Minnesota from Lake Itasca in the north to the village of Jefferson in the south.

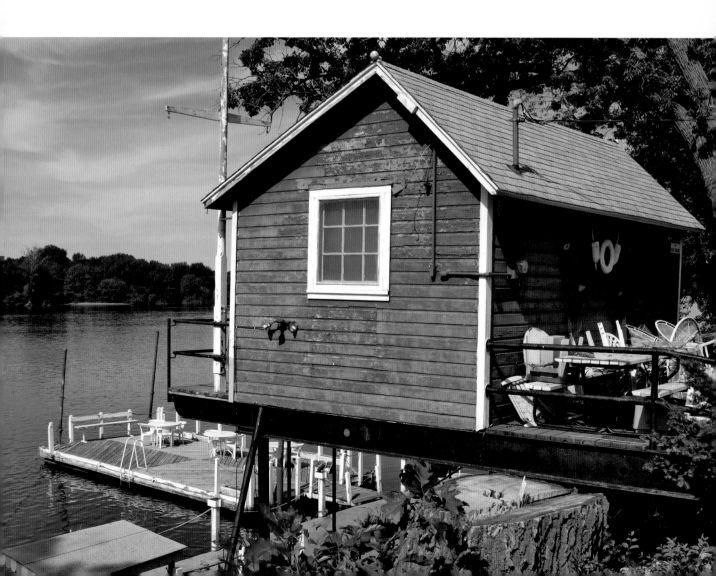

2

Cabins are of many kinds;

their job is to suit their occupants.

Thoreau was by no means the first to retreat from daily life to his lake or woods cabin. The private hut boasts an old and honorable lineage—not only in America, but anywhere on the planet where noise and ambition and getting and spending weary the spirit. W. B. Yeats was only twenty-seven years old in 1893 when he wrote his famous poem, "The Lake Isle of Innisfree":

> *I will arise and go now, and go to Innisfree,*
> *And a small cabin build there, of clay and wattles made:*
> *Nine bean-rows will I have there, a hive for the honey-bee,*
> *And live alone in the bee-loud glade.*
>
> *And I shall have some peace there, for peace comes dropping slow,*
> *Dropping from the veils of the morning to where the cricket sings;*
> *There midnight's all a glimmer, and noon a purple glow,*
> *And evening full of the linnet's wings.*
>
> *I will arise and go now, for always night and day*
> *I hear lake water lapping with low sounds by the shore;*
> *While I stand on the roadway, or on the pavements grey,*
> *I hear it in the deep heart's core.*

I had never thought much about this old plum of a poem until I found myself teaching it to a class of Chinese graduate students in Xi'an in 1986. I was assigned to teach British literature and was given Professor Chen Jia's famous anthology to teach from. Chen Jia had trained in Moscow in the thirties so his anthology had passed Marxist political muster; it was safe for Chinese students. Some odd selections puzzled me at first: twelve lines of Yeats, next to forty pages of Robert Tressell's *The Ragged Trousered*

PREVIOUS PAGES Big Birch Lake, Stearns County

Philanthropists. I'd never heard of it, but neither had most products of American graduate schools. I photocopied Yeats's "Easter 1916," "The Second Coming," and a few Crazy Jane poems, but began the course with Chen Jia's selection. Here's his commentary: "Tired of the life of his day, Yeats sought to escape into an ideal 'fairyland' where he could live calmly as a hermit and enjoy the beauty of nature." The class Party monitor pointed out that this was pure bourgeois nostalgia. In retrospect, I think he's right, though I resisted the notion at the time.

On the other hand, what's wrong with a little bourgeois nostalgia? It's a lovely poem, if a little self-consciously romantic

Nine bean-rows will I have there,
a hive for the honey-bee,
and live alone in the bee-loud glade.

W. B. Yeats

31

ABOVE "Beach Cabin" (1920), located on the west shore of Otter Tail Lake, Otter Tail County

for an ambitious twenty-seven-year-old to whom not much had happened. If Yeats had written it at sixty or at eighty, we might believe it. Any who treasure a renewing landscape—a Walden somewhere—hear the lapping of lake water "in the deep heart's core." Not even political correctness—Marxist or otherwise—can alter that bottom fact in human beings. My Chinese students, who were smarter than their political leaders, understood that in Yeats, though they much preferred his bawdy old-man poems.

Yeats hadn't experienced quite enough failure at twenty-seven to deserve his nine bean-rows and bee-loud glade. Middle age remedied this shortfall of experience, as it so frequently does for us all. Maud Gonne, his heart's desire, rejected him for the final time after almost thirty years' pursuit. Ireland was in the middle of bloody turmoil and revolution. World War I had come and gone. He'd managed a theatre with all its attendant gossip, meanness, and jealousy. He'd buried friends like John Millington Synge. In 1918, at fifty-three, he bought and moved into his "adult" cabin: no clay and wattles or slow-dropping peace, but Thoor Ballylee, a medieval Norman roundstone watchtower overlooking the pounding of the stormy North Atlantic. Here he retreated, and here, for a while, he wrote. Maybe Chen Jia was right about "fairyland." We invent the cabin our lives suit us for. Maybe the mistake my freshmen students made was trying, too young, to imagine their proper retreat at forty. By forty, the retreat might be simpler, rougher, and further away from the long freeway commute and the sealed, smoke-free office.

ABOVE Cabin window, Norway Lake, Barclay Township, Cass County

32

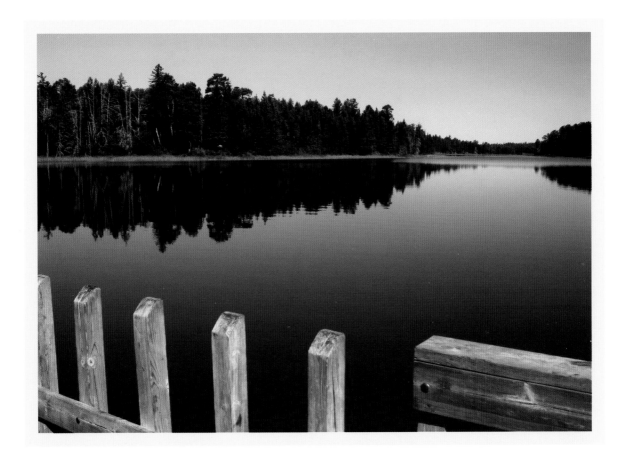

ABOVE Lake Itasca, Clearwater County. The Mississippi River begins its long journey (2,320 miles) from this tranquil lake in northern Minnesota. The lake is one of the highlights of Minnesota's oldest state park, Itasca State Park, established in 1891. Cabins built during the 1930s are still available for public rental.

The ancient Chinese and Japanese Buddhists certainly thought so. There's a long and marvelous tradition of "hut writing," descriptions of retreats from the neurotic hazards of court life, and uncertain careers in the official bureaucracy. Burton Watson has translated a selection of these essays in *Four Huts: Asian Writings on the Simple Life*. These are Thoreau's (and Yeats's) true grandfathers. In all of them, "The house becomes a metaphor for the householder"; they convey "their underlying sense of the world and what is to be valued in it." All four authors are poets and "all mention musical instruments or the pleasure they derive from music. . . . Certain ideas run through all the pieces—love of nature, poetry and music, simplicity and the quiet life." The dates of the essays range from 817 to 1690. The questions that underlie them: What constitutes happiness in this life? How should we pursue it? What are its minimum requirements? They are the same questions Thoreau—and my students—still ask.

What constitutes happiness in this life?
How should we pursue it?

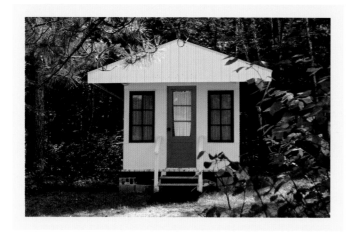

What answers do they give? Po Chü-i (or in the new spelling, Bai Juyi), one of the great poets of the T'ang Dynasty, *one* of the several golden ages of Chinese poetry, says that when he saw the peak of Mt. Lu he "fell in love with it"; so, in 817, he "set about building a grass thatched hall." He makes a north door for cool breezes, a south door for sunlight, and inside "one lacquered *ch'in* [a Chinese lute] and some Confucian, Taoist, and Buddhist books, two or three of each kind." He contemplates Mt. Lu:

ABOVE Wabana Township, Itasca County

34

"Trees and bamboo, the clouds and rocks, busy with them every minute from sun-up to evening." That's the right busy-ness in your cabin, too. To what effect all this watching?

One night here and my body is at rest, two nights and my mind is content, and after three nights, I'm in a state of utter calm and forgetfulness.

At that point, neither you nor Po Chü-i want to saddle up the family van to return for the Monday commute, the Tuesday staff meeting, the Wednesday PowerPoint presentation, the Thursday business lunch, then the Friday remounting the chariot for the quick trip north for a little more of that calm and forgetfulness, a few hours of *ch'in* practice, and a couple of Taoist poems to cap the day.

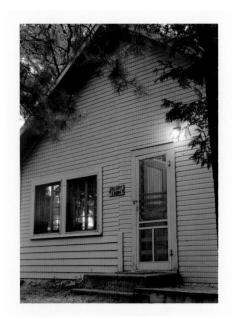

Po Chü-i acknowledges your dilemma since he shares it: "I'm saddled with my post as a supernumerary official, and with other entanglements I can't get free of just now, so I come and go, not yet able to sit down and rest." Some day, after he resolves his entanglements, he intends to gather up his ch'in and books and "live out the remainder of my days here. . . . You clear spring, you white rocks, listen to what I say!" But they didn't. How like all of us is this ancient Chinese poet. There is no surprising news here at all.

35

*One night here and my body is at rest,
two nights and my mind is content . . .*

Po Chü-i

In 1212, three centuries after Po Chü-i, Kamo no Chōmei, a Kyoto native, describes his retreat to the "ten-foot-square hut." In Japanese, *hōjō* (one *jō* square) is equivalent to ten *shaku* or feet. Kamo alludes

ABOVE Ten Mile Lake, Shingobee Township, Cass County. The cabin, the oldest on Ten Mile Lake, was built in 1910.

to an ancient Buddhist sutra by Vimalakirti who meditated in a ten-foot-square hut. Maybe that exact size is traditional. Thoreau, well read in ancient Asian literature, probably knew some such tradition when he built Walden, but decided (in classic cantankerous Thoreauvian manner) to observe it only halfway. The Walden cabin was ten by fifteen feet. That qualifies as a hut, neither a mansion nor villa.

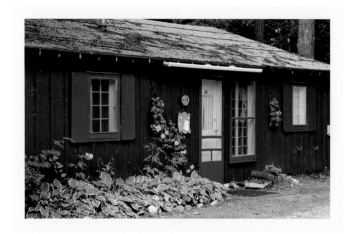

I desire only a peaceful spot,
and delight in being free from care.

Kamo no Chōmei

Kamo begins his essay with a description of the events of his adult life: huge city-destroying fires, earthquakes, famines, what Kamo calls "whirlwinds," but what a Minnesotan would call a tornado, profound personal and professional failure, corrupt government, and poverty. It's a good list of disasters—all-inclusive. So Kamo, at fifty, an old age then, gives up the secular life, becomes a Buddhist monk, and retreats to the hills. Now that he's reached sixty "when life fades as quickly as dew, I've put together a lodging for my final days, like . . . an aging silkworm spinning its cocoon. . . . As my years have grown in number, my houses have gotten smaller and smaller." Ten feet square, less than seven feet in height, dirt floor, thatch roof, fern fronds for a bed, a little Buddhist shrine to Amida, with a copy of *The Lotus Sutra,* three bamboo shelves for books on Japanese poetry and music, and "beside them my *koto* and my *biwa*" (two Japanese plucked instruments, one like a dulcimer, the other like a lute). "Small as it is," says Kamo, "it provides room enough to sleep

ABOVE Wa-Ga-Tha-Ka Resort cabin (circa 1920) on Lake Wabana, Itasca County. In Ojibwe, Wa-Ga-Tha-Ka means "dwelling place among the birches."

at night and to sit in the daytime, all that is needed to accommodate one person. The hermit crab prefers a little shell because he knows the dimensions of his own body. . . . I am the same. Knowing my own size and knowing the ways of the world, I crave nothing, chase after nothing. I desire only a peaceful spot, and delight in being free from care."

So far in this essay, we have visited the cabins of writers. Books are not made in crowds, nor do words flow in the presence of extraneous noise. To write, to think, needs a table, a seat, a pencil, a brain, silence, and privacy. Nature helps for some writers, but I've known some who work best in the middle of a noisy city, in a small room with a lock on the door. Cabins are of many kinds; their job is to suit their occupants. Robert Bly wrote in summer cabins on Big Stone and Kabekona lakes, and at home, first in a small

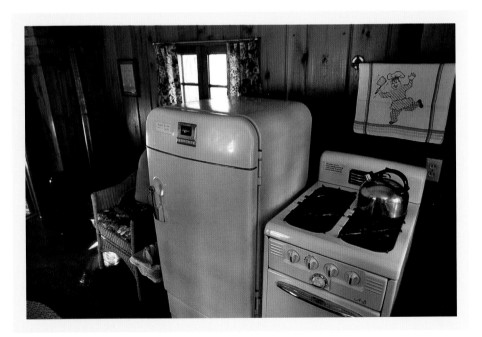

ABOVE Cabin interior, Island View Resort (1937), on the north shore of Lake Superior, Lake County

chicken house, then in an old country schoolhouse on his farmstead. My neighbor Fred Manfred, the novelist, who was 6 feet 9 or 10 inches, wrote in a hut smaller than Kamo no Chōmei. There was hardly room for Fred's elbows and knees, much less his typewriter or the complete multivolume *Oxford English Dictionary* that he insisted on having always at arm's length

when he wrote. Arthur Miller built his own ten-by twelve-foot cabin, though by his own testimony, he was a more incompetent carpenter than Thoreau. There he wrote *Death of a Salesman.* Was Willy Loman born of Miller's manual labor? David McCullough, the historian, invents his fat books on American history in a twelve-by eight-foot cabin. Ole Rolvaag, after escaping his teaching job at St. Olaf College, fled north

to a small log cabin in the pine woods for the summer where he wrote all his novels. Mahler composed his mammoth symphonies every summer in a small cabin in the mountains of Austria, after he had finished the opera season in Vienna. Richard Flanagan and Nicholas Shakespeare both write their novels in small dark cabins on the Tasmanian coast in the Indian Ocean south of Australia. They sit with their backs to the sea so that they can get something done. That much beauty takes the mind off any labor.

Writing is, of course, a silent art. So is most composing; Mahler needed only music paper and silence to hear the orchestral lines moving through his head. But remember Thoreau's flute, Po Chü-i's *ch'in,* Kamo no Chōmei's *koto*? No cabin is complete without music. Yoshishige no Yasutane, another Japanese hut dweller in 982, plays no instrument but after his supper, a sutra

or two, and a while with his books, he confesses that "I close my gate, shut my door, and hum poems and sing songs by myself." I love the next sentence too much not to quote it for you: "If I have some free time left over, I call the groom and we go out to the vegetable garden to pour on water and spread manure." There's a kind of music in that, too!

What about professional performing musicians who must, of course, practice every day, but like the rest of us need a periodic cabin retreat and renewal? Jussi Björling, one of the greatest singers of the twentieth century, was endowed with a silvery tenor of great lyrical beauty. He was also the pride of Sweden. His career began in the twenties as a boy singing with the Björling family quartet, touring every hamlet in the country, singing folk tunes and hymns on Swedish state radio. "Tonerna" or "Varmeland" could reduce otherwise phlegmatic Swedes to blubbering. As a grown man, his Puccini and Verdi sold out opera houses all over Europe and America.

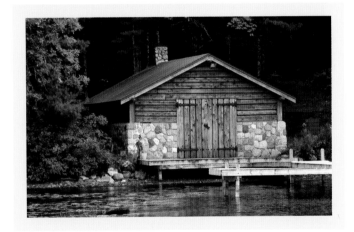

Like most Swedish families, the Björlings owned a summer *stuga*, a retreat to nature for the brief, intense arctic summer of continual light. But singers vocalize daily to keep their instrument tuned and supple. To learn a new role for the opera season requires hundreds of hours of practice. The Björling family owned a small island in the Stockholm archipelago, with a comfortable and commodious house for guests, children, long summer dinners with herring, boiled potatoes, pickled beets, *gravlax,* cream cakes, *aquavit,* and probably croquet on the lawn. Imagine Ingmar Bergman's *Fanny and Alexander.*

ABOVE Boathouse on Bay Lake, Crow Wing County

ABOVE The end of a perfect day. Pelican Lake, Minnewaska Township, Pope County. Minnesota ranks fourth behind Florida, Michigan, and California in the number of boats registered.

But for Jussi, there was work to do, so he commandeered a small cabin next to the lakeshore, moved in a piano, and created his studio. There he disappeared daily to vocalize and memorize. But an operatic tenor of his size and penetration is a bit hard to muffle. *Vesti le Giubba* is hardly silent. On the other hand, it is very beautiful. Björling's voice was of such quality that even a simple scale or arpeggio could bring pleasure. Remember also that Jussi rehearsed on the lakeshore and sound carries with astonishing clarity and distance over water. Neighbors from miles around that galaxy of small islands must have heard the bell tones of the great man at work. Being Swedes and simultaneously loving his voice, they wanted to listen but not to cause a fuss. They drifted past in their canoes or small boats, extinguishing the motors or rowing as silently as they could past the music. There they floated as slowly as possible as *Il mio tesoro intanto* or *Una furtiva lagrima* or *Ingemisco* undulated out over the glassy surface of the lake in the long white light. Björling's son Anders remembers an endless parade of boats moving silently past the studio for this watery glorious concert. What did they do when the great man, needing a cup of coffee or a pee, stopped singing and opened the door. Did they applaud? Wipe tears from their faces? Or being good Swedish neighbors did they nod politely, or cast rods into the water as if just passing by hunting for a breakfast pickerel? That scene and the thought of that music make me wish I had been there. There's always the possibility of magic in your version of the ten-foot thatched hut, even if it is only the scattering of manure with the groom after a good sing of ancient poems. 🖋

There's always the possibility of magic in your version of the ten-foot thatched hut. . . .

BELOW Rustic cabin on the south shore of Lake Belle Taine, Nevis Township, Hubbard County

RIGHT Unique cabin built in the shape of a riverboat, Lake Bemidji, Beltrami County

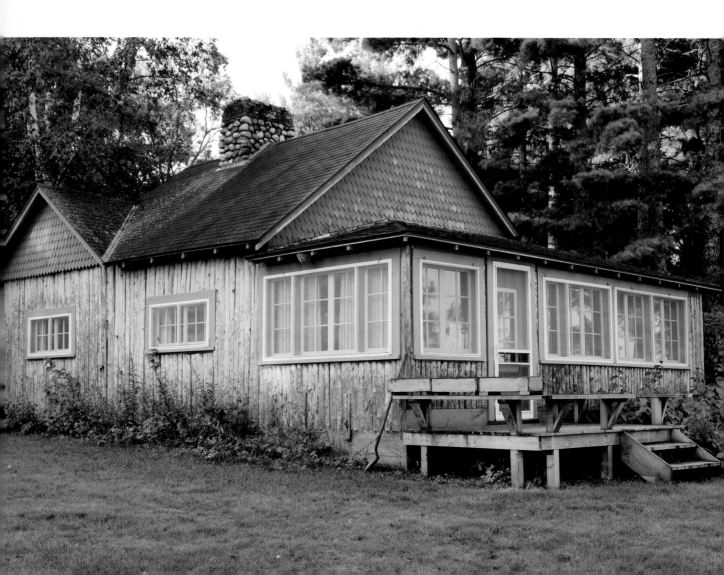

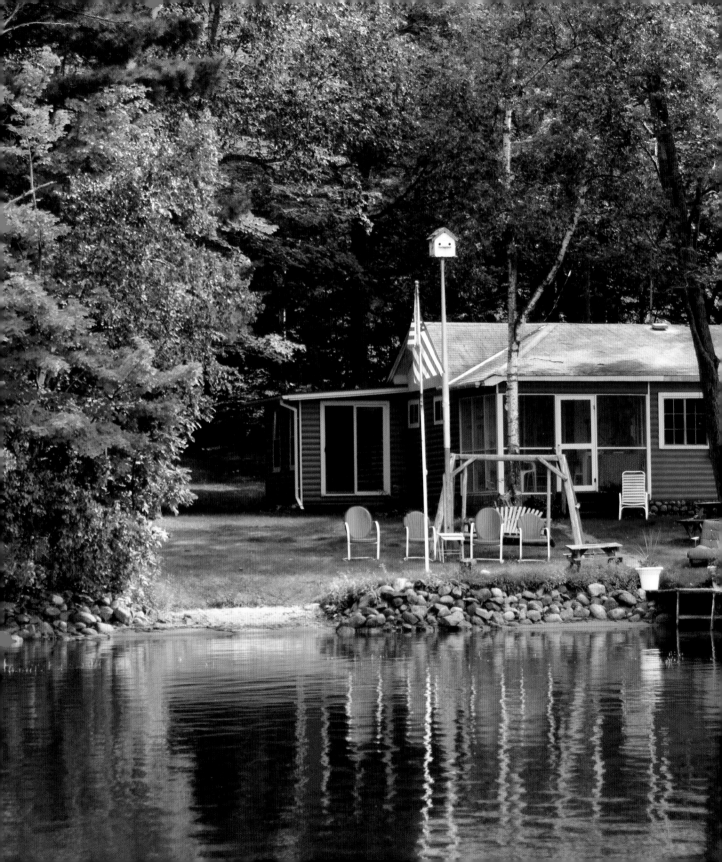

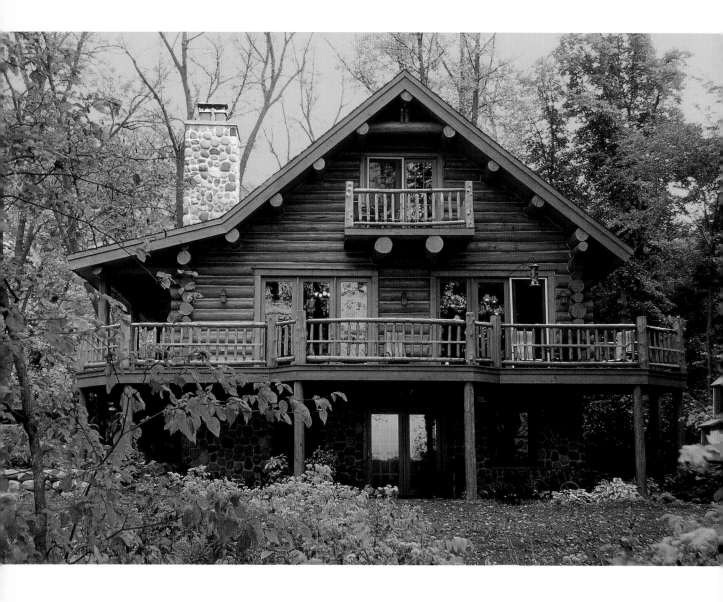

PREVIOUS PAGES Lakefront cabin, Bay Lake, Crow Wing County

ABOVE Custom log cabin built on Sauk Lake, Sauk Centre Township, Stearns County

BELOW Cabin on Eleventh Crow Wing Lake (circa 1920), Akeley Township, Hubbard County

NEXT PAGES, LEFT Parkers Prairie Township, Otter Tail County

NEXT PAGES, RIGHT Deer hunting stands become temporary cabins for many Minnesotans in November. Rosing Township, Morrison County. According to the Minnesota Department of Natural Resources, deer hunting popularity is on the rise in our state. In 2006, license sales were 404,000, compared to 397,000 in 2005.

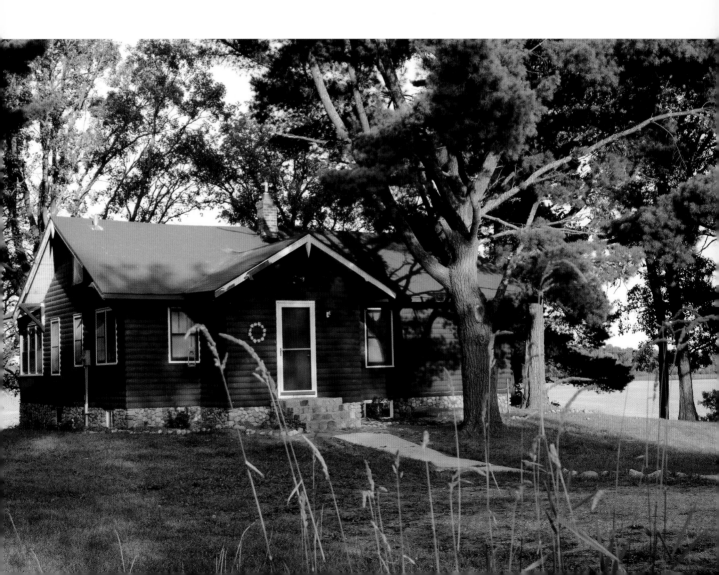

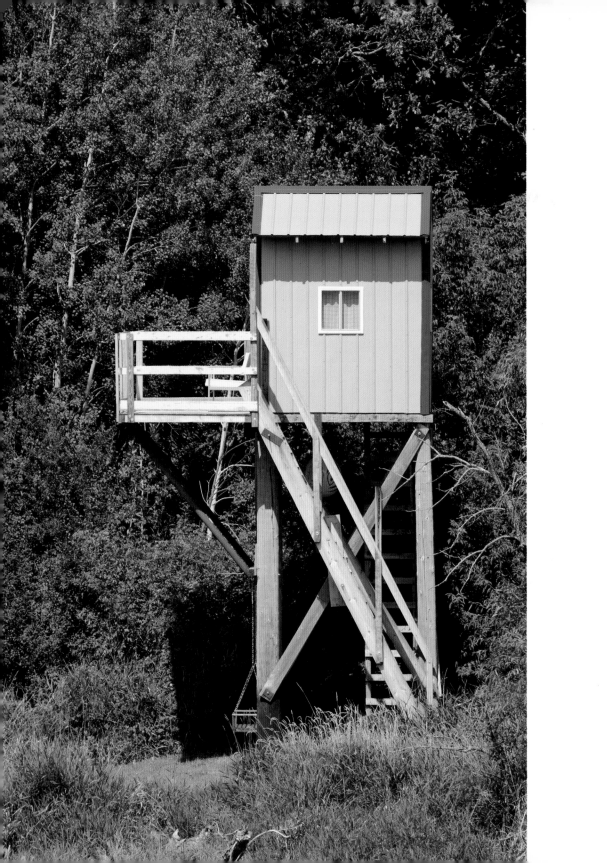

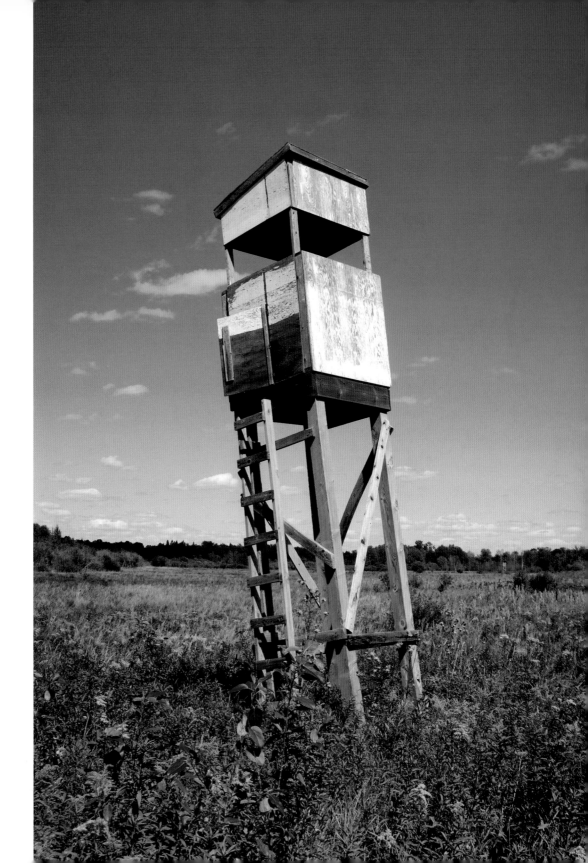

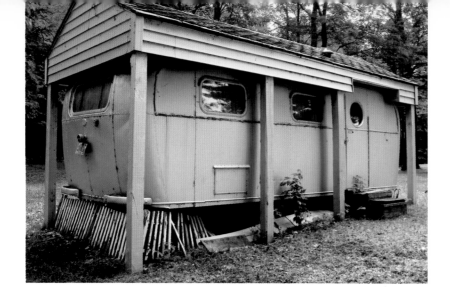

ABOVE Customized Airstream camper makes for a cabin retreat on Lower Whitefish Lake, Crow Wing County

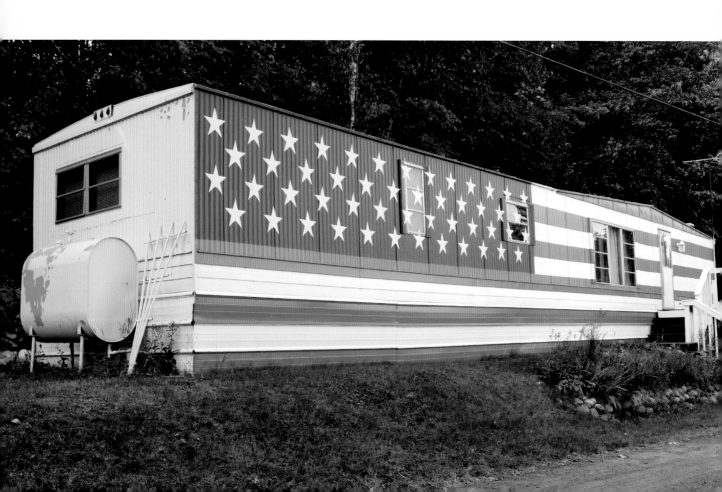

LEFT A patriotic trailer overlooks the west shore of Big Sandy Lake, Libby Township, Aitkin County

ABOVE A permanent campsite with trailer on the east shore of Mille Lacs, Lakeside Township, Aitkin County

3

We get to live—for awhile—
the life we imagine,
because it is necessary for our sanity,
our balance in the world.

minnesota touts itself as the "Land of Ten Thousand Lakes." That is, in fact, a modest boast: diffident arrogance. There are more . . . probably 15,000, depending on how you count prairie sloughs and potholes or how much progress we have made in draining them all. That is a lot of lakefront real estate, but despite our abundance we have been very busy moving it from seller to buyer and back and forth. I think it's safe to claim, modestly, that there is a living to be made in this market. The idea of the summer cabin, the lake house, the woods retreat, the *stuga,* is buried deep in the psyche of the state's culture. Minnesota was settled by (and is still inhabited by) a couple of million Norwegians and the better part of a million Swedes for whom the *stuga* is not an option but a religion.

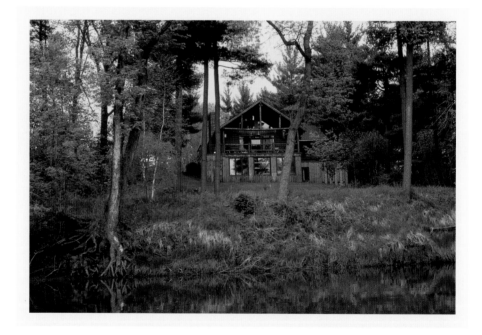

PREVIOUS PAGES Lake Alexander, Scandia Valley Township, Morrison County

ABOVE Cabin on the Rum River, Isanti County.

I am your guide on this little cabin survey, and can probably be trusted. I am a genuine native Minnesotan with three generations marked in a local graveyard to prove it, and though neither Norwegian nor Swedish, I feel the same interior allure of cabin life. That allure is not ethnically bounded; it is diverse, probably the result of weather, atmosphere, or eating locally caught fish. I can furthermore be trusted

because I am not in the real estate business. No special deals from me. Contrary to my father's good advice, I went into poetry, so I don't even *own* a cabin in Minnesota. (I have one elsewhere, but more of that later.)

My father, the advisor, farmed on the treeless, lakeless prairies, eight miles north of the nearest village. I knew no farmers in the 1940s or '50s who owned lake cabins, or even any who rented them for family vacations. The idea of a retreat would have seemed ridiculous to Alphonse Eggermont or Otto Severson or Benny Sturm or Big Bill Holm. If you wanted privacy, go down to the barn, or out into the grove. If you wanted "nature," mount your tractor (or your team of horses) and plow, plant, cultivate, mow, combine. Only the village businessmen, or professionals, had either money, time, or inclination to own a lake retreat. Their most frequent local destination was the spring-fed Lake Cochran, just over the border in South Dakota. Some of these cabin dwellers came closer to nature

The idea of the summer cabin, the lake house, the woods retreat, the stuga, is buried deep in the psyche of the state's culture.

ABOVE Log Cabin Motel and Grill (1947), Olmsted County. In 1947, on old federal highway 52 near Rochester, Ben and Helen Mitchell began building their vintage motor lodge cabins and café. Helen still opens the café to serve her famous sourdough pancakes, but you better come early: the sourdough batter runs out by 9:00 A.M.

in summer by surviving without electricity, running water, and indoor plumbing. On the farm we already had all these "natural advantages": only an outhouse, a pump in the kitchen, a wind generator for power, a cistern—and no telephone (much less any subsequent inventions). My idea of a summer cabin as a boy was a deluxe room (with room service!) at the Leamington Hotel in Minneapolis and an unlimited charge account at the Dinkytown bookstores. We had quite enough nature and solitude in Swede Prairie already (and plenty of manure to spread after a songfest). The 1885 shack of a farmhouse built by my grandfather was cabin enough. The north wind howled in through the rattly windows, and honey from the bees trapped in the walls oozed out between loose cracks. It still strikes me a bit odd that ordinary middle-class people expend large amounts of money and energy to own and to experience what most of the human race enjoyed for most of its history over the whole planet. Odder still, I want it myself, now.

The desire for cabin life is, of course, the by-product of our overwhelming urbanization.

The desire for cabin life is, of course, the by-product of our overwhelming urbanization. Living in a crowded, frenzied city with its dirt, noise, crime, squalor, stalled and immobile traffic, and daily rudeness causes one to make mental pictures of a windy night on a lake, a fireplace burning, someone quietly (but skillfully) strumming a guitar, a black pot of aromatic venison stew filling the air, a not-bad red wine in an old jelly

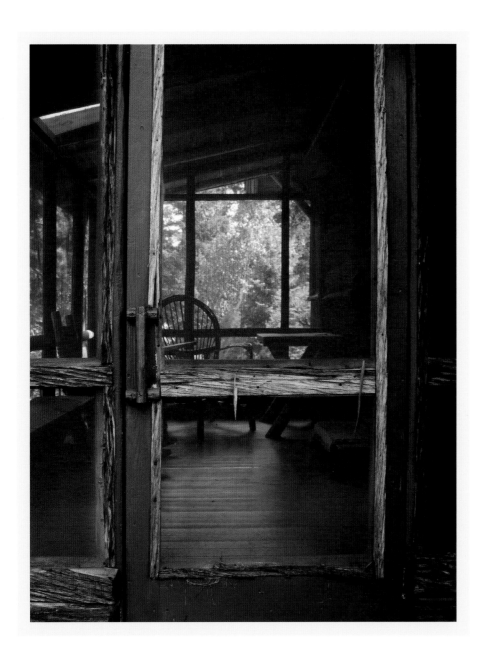

ABOVE Porch on "Ober's House," Mallard Island

glass (lake dishes, you know . . .), a voice reading an old poem aloud, maybe Frost's "Two Look at Two," Elizabeth Bishop's "The Fish," or one of Robert Bly's shack poems, a few fat raindrops now striking the big window that opens to a scene of lake water, sky, tree shadows. This is, I hope, what my students had in mind for their cabin joy. It's a mental picture worth making.

Bringing this picture to life in reality, though, requires surplus income from a job, well-off ancestors, or a decent pension. The true poor do not imagine cabins; they imagine their next meal or a warm coat. Neither Thoreau, Yeats, Po, nor Kamo were poor by this definition. Thoreau's family owned a pencil factory. He had the best (and most expensive) education America could provide (a Harvard man!), he had been both a schoolteacher and a surveyor, and he knew Emerson, who was reasonably well-off. He

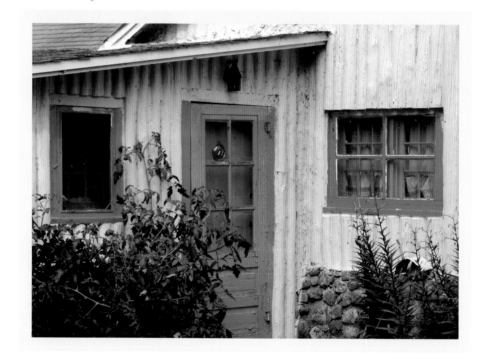

ABOVE Big Sandy Lake, Libby Township, Aitkin County

says, "None can be an impartial or wise observer of human life but from the vantage point of what we should call voluntary poverty. Of a life of luxury, the fruit is luxury." Every spiritual manual, whether *The Rule of St. Benedict,* the Buddhist Sutras, the *Tao Te Ching,* the meditations of Marcus Aurelius, or any other tradition I know, all commend what Chaucer called "glad poverty." Thoreau says, in addition, that "the most interesting dwellings in this country, as the painter [or photographer!] knows, are the most unpretending, humble log huts and cottages of the poor . . . since their architectural beauty . . . has grown from within outward, out of the necessity and character of the indweller, who is the only builder—out of some unconscious truthfulness, and nobleness . . . and is preceded by a like unconscious beauty of life."

> The most interesting dwellings in this country . . . are the most unpretending.
>
> *Henry David Thoreau*

So in our cabin retreats we play at poverty: not in the silly sense of child's play, but in the sense of the imagination at play. We get to live—for awhile—the life we imagine, because it is necessary for our sanity, our balance in the world.

An old friend of mine, David Wold from St. Paul, moved to Sweden thirty years ago. He lives in Säffle, a paper mill town on the shore of the big Lake Vanern. He has worked as a translator and editor and has an ordinary Swedish life. His Swedish wife Inger is a schoolteacher. His sons speak English with a Swedish lilt. His next door neighbor Lennart is the chief of police. Tourists do not come to Säffle. It is a real place. No Europeans (or anyone else I know about) are more in love with their summer retreats than the Swedes. The Swedish word is *stuga* (*stugor,* plural). I wrote to David to ask him what he knew about the psychology of the *stugor.* It's a source that probably ought not to be neglected in thinking about cabins. This is what he had to say:

ABOVE Jon Boat and cabin on the Mississippi River, Winona County. Jon Boats are ideal
for exploring the Mississippi River and its shallow backwaters.

From the information I've gathered so far, the psychology behind stugor *in Sweden or "Why are Swedes so eager to retreat to somewhere else in the summer?" more or less boils down to swapping a long, cold, dark and dreary winter for a short, reasonably warm, light and pleasant summer close to nature. Given this desire to get away from it all, Swedes retreat to traditional summer homes along-side a lake or waterway. But* stugor *aren't their only places of escape.*

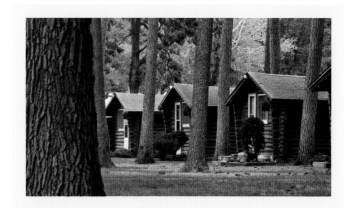

They also withdraw to former torp *or crofter's cottages, to* soldat-torp *or former tenement soldiers' cottages, to former farmhouses, which current city dwellers have inherited from their farmer rela-tives, or to other accommodations, such as sailboats and motorboats. All of this retreating is, of course, enhanced by a generous holiday period, a gift of the welfare state, which has for many years virtually closed down Sweden during July and the first half of August.*

The summer stuga *also has class implications. For instance, some people I've talked to suggest that the working class tacked together the traditional very simple* stugor *built alongside lakes and waterways*

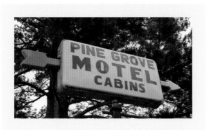

from scrap materials they could gather from here and there. This happened during the time of Sweden's rapid industrialization in the forties and fifties, they say. White-collar workers chose other means of escape.

ABOVE Pine Grove cabins on the Snake River in Mora, Kanabec County. Family-owned motels were a common sight along Minnesota roads well into the 1960s.

David is too sensible to imply what I suspect: that inside every Scandinavian (or every survivor of long dark winters, wherever they rage) lives an interior Pantheist—a worshipper of god in nature, rather than in the supernatural. Watch the faces of any northerners on the first truly warm sunny day in June when the light begins to last till August. Their eyes close; their faces open and turn toward the light like sunflowers, a look of pure joy. For Minnesotans, this joy is compounded by the sound of the ice crackling and dissolving on the lakes and rivers. Poor Swedes! Neither the Baltic nor the Atlantic freeze dependably in winter, so they mostly miss this joyful noise.

Watch the faces of any northerners on the first truly warm sunny day in June. . . .

62

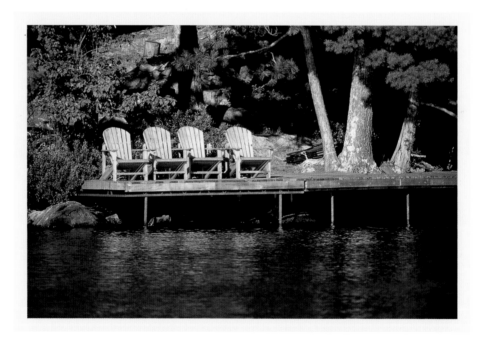

ABOVE Lake Vermilion, St. Louis County

ABOVE **Ida Lake, Candor Township, Otter Tail County. As soon as it's "ice out" in the spring, the cabin season starts.**

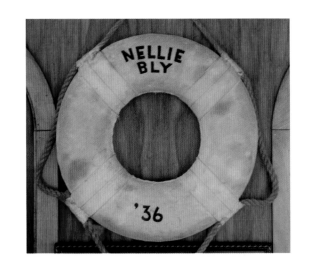

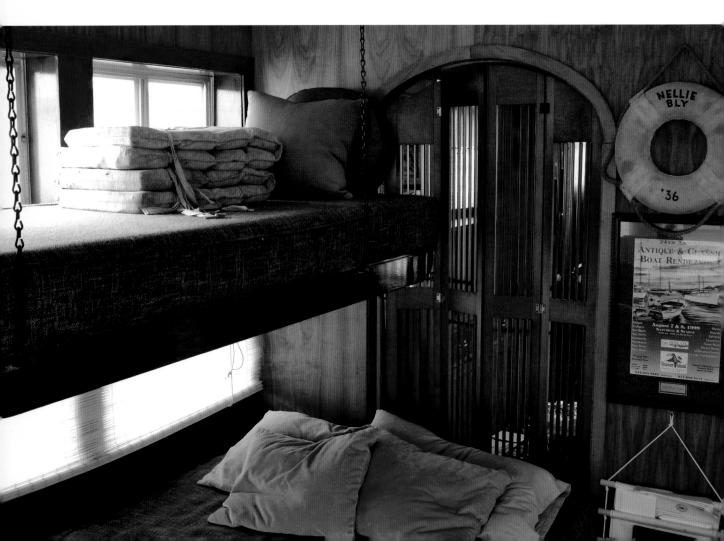

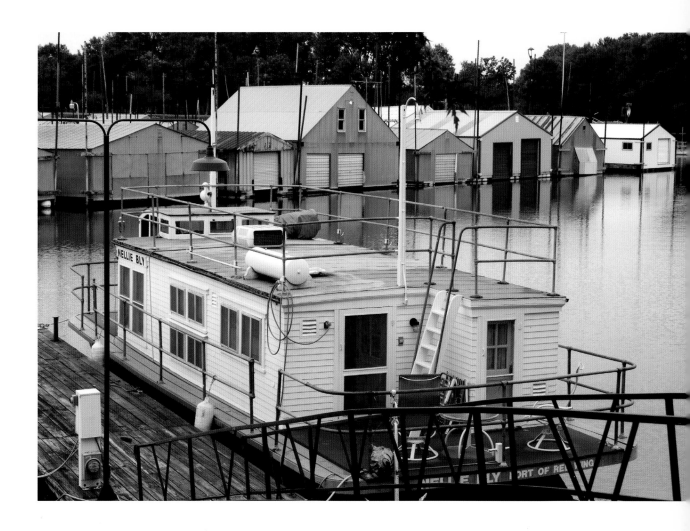

LEFT AND ABOVE Nellie Bly houseboat on the Mississippi River at Red Wing, Goodhue County. The houseboat was built in 1936 by local craftsmen from Red Wing for Mr. Stanley G. Gray of Edina. After nine weeks of construction the 42-foot "Nellie Bly" was launched. Later that year Mr. Gray gave the houseboat to his daughter Marjorie and son-in-law, Arnold Vogel, as a wedding gift. Today, Marjorie, at age 94, along with her grandchildren, continues to use the boat.

BELOW Sinclair Township, Clearwater County. This cabin was originally built in 1881, near Detroit Lakes, on the Cottonwood River, the homestead of Norwegian immigrants, Kittle and Kari Olson Saete. The building remained in the family until their last son passed away. For many years the cabin was left vacant until it was dismantled and moved by the current owner to a site in Clearwater County. The original footprint of the building has been maintained, as well as the location of all the windows on the first floor. Local craftsmen reassembled the building, adding freshly cut logs from the new site to replace logs that had rotted. The structure is now used as a vacation home.

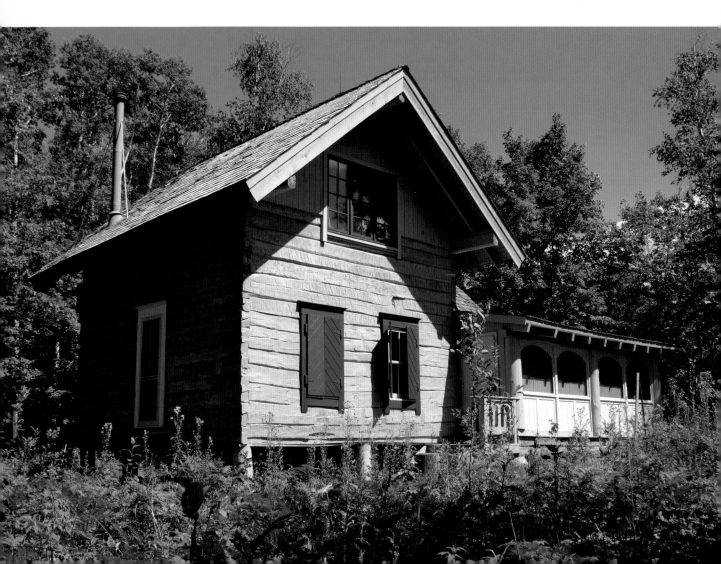

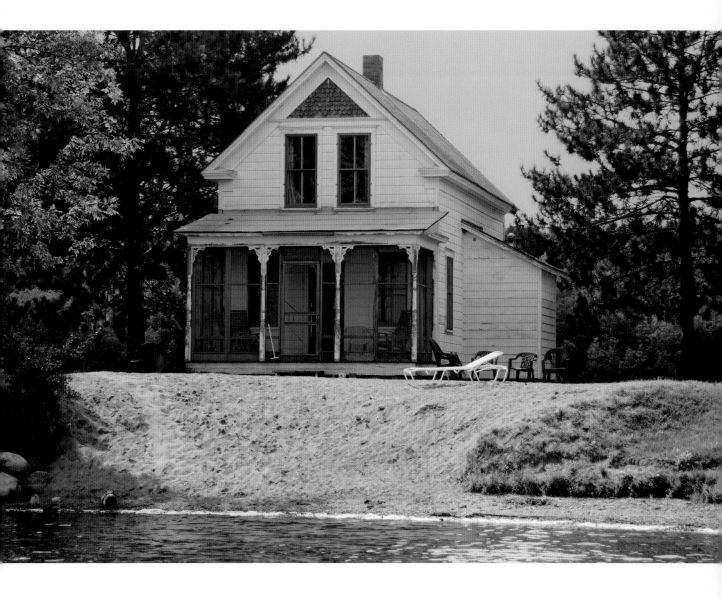

ABOVE Bay Lake, Crow Wing County. Known locally as "Cottage on the Point," this Greek Revival house (circa 1890) is one of the original homes built on Bay Lake. Today the house is rented out as part of Indian Point Resort.

NEXT PAGES The "Garden Cottage" at the Gardner's Greenhouse (circa 1900), Leech Lake Township, Cass County. The cabin was once part of a local resort, the Bay View Resort, but has since been moved. Today the current owners use the cottage in their greenhouse and nursery business.

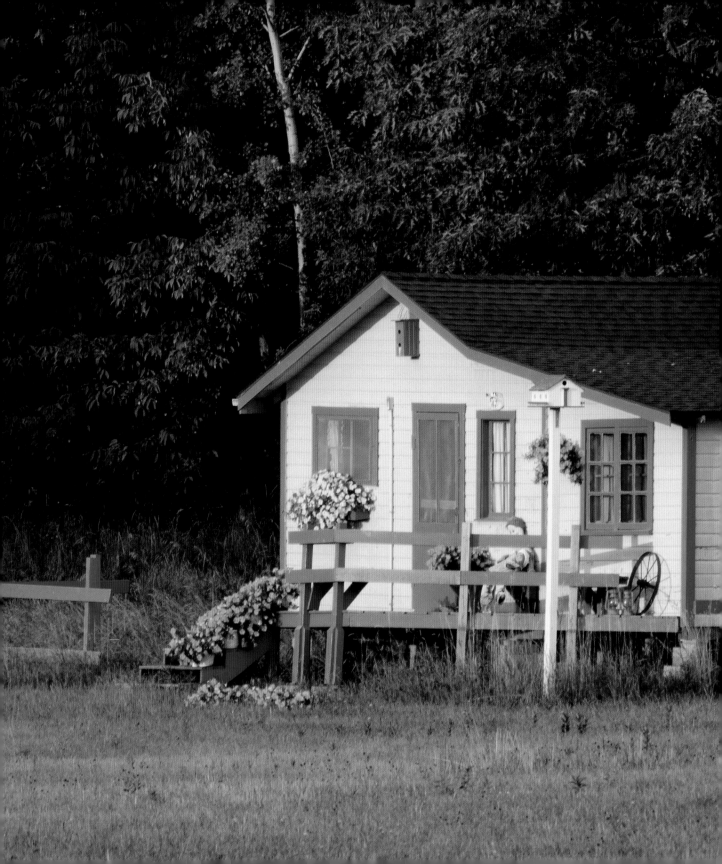

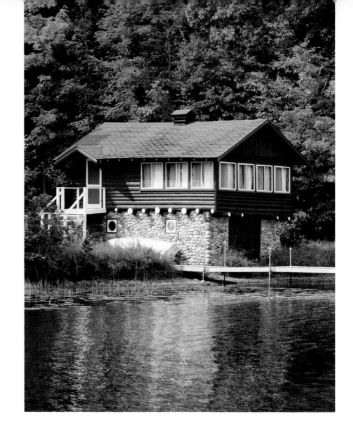

LEFT, TOP Cabin and boathouse on Bay Lake, Crow Wing County

LEFT, BOTTOM Pelican Lake, Crow Wing County

BELOW Sand Point Lake, Voyageurs National Park, St. Louis County. Voyageurs National Park, 36th in our National Park System, was established in 1975. Today the few cabins that remain within the borders of the park were protected by special permits issued by the federal government at the time of park designation.

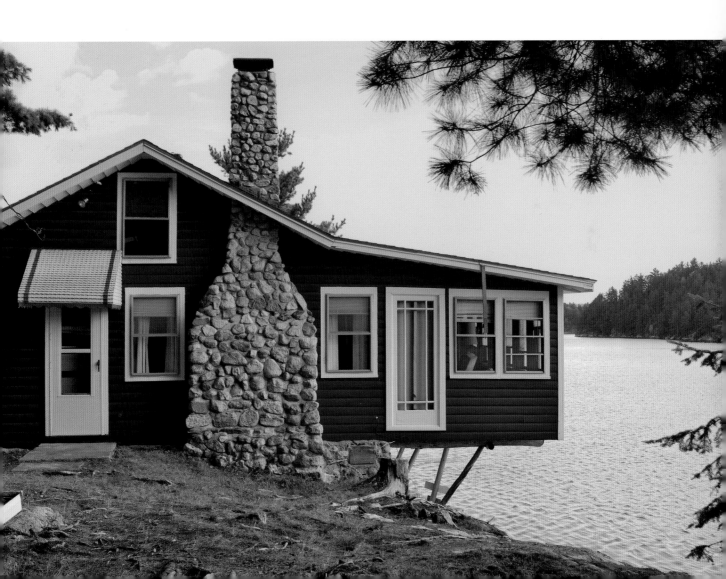

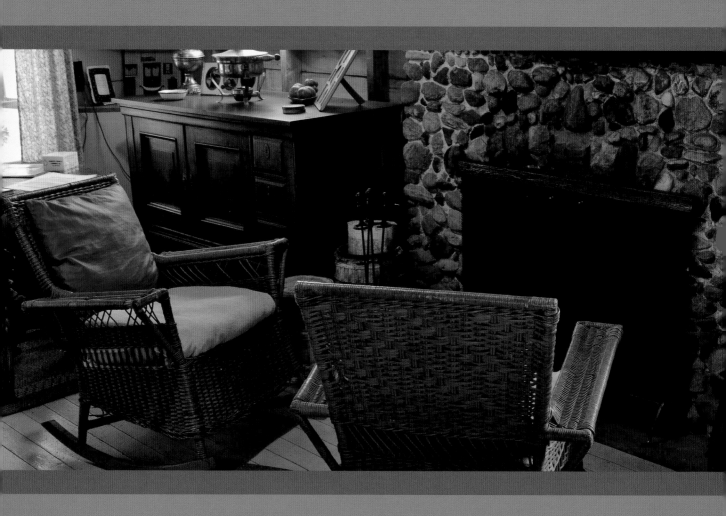

4

Hospitality is a
 grand cabin tradition.

\mathcal{S}canning the local newspaper in April, I found an announcement for a *Cabin Life* show at the Minneapolis Convention Center. Aside from speeches on septic systems, and how to recognize North Woods birds, one speech caught my eye: "Cabinology 101" by Dale Mulfinger, a Minneapolis architect and author of two lovely books on cabins he's either designed or admired: *The Cabin* and *The Getaway Home*. After the books appeared, Mulfinger was humorously christened a "cabinologist" by a local journalist. "Saved me from having to get a Ph.D.," Mulfinger said. In an interview, Mulfinger describes his style as "whimsical agrarian—based on barns, sheds, and other Midwest farm buildings." Among his designs are a cabin modeled after a chicken coop for an art

historian and a four-level, "sky-high" treehouse on Lake Vermilion built to resemble a tin-clad silo.

His comments in *The Cabin* are eminently sensible:

> *In function—if not always in form—modern cabins are no different from historical ones, except that people today don't usually live in their cabins full-time. We escape to them instead.*

What is a cabin? How do we distinguish it from a house? Mulfinger lists four cabin characteristics:

(1) "The site is chosen for its natural beauty." (Remember Po Chü-i's confession that he "fell in love" with Mt. Lu and the views?)

PREVIOUS PAGES Cabin interior, Pokegama Lake, Bass Brook Township, Itasca County

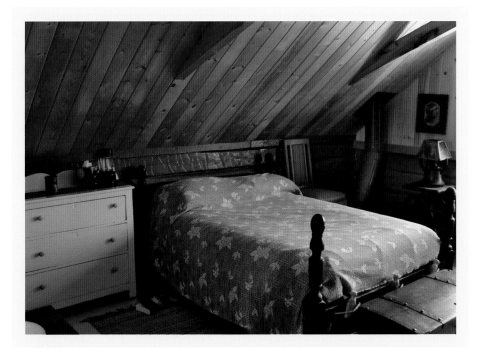

(2) "A cabin provides simple, basic shelter. It isn't fancy. It doesn't try to make a social statement, as houses often do. A small efficient floor plan is all it needs."

(3) "Overlapping activities take place within the compact quarters." (Practicing the flute, reading *The Iliad* in Greek, singing old poems, spreading manure, catching walleye for breakfast.)

(4) "Everybody feels at home right away. A cabin's furnishings are simple, often treasured family hand-me-downs. Its sleeping lofts, tucked under the eaves, evoke memories of childhood. Its fireplace or wood stove provides physical and emotional warmth." (Remember Thoreau putting Hosmer at his ease with games, languages, stories, and roast horn pout? Hospitality is a grand cabin tradition.)

ABOVE Attic bedroom, Sinclair Township, Clearwater County

Mulfinger has a couple of other sensible rules, too. A cabin must "respect the environment . . . enhance the landscape, not overpower it." The cube, or rectangle, "is still the most common cabin form." (10′ by 15′, Walden; 10′ by 10′, thatched hut.) Cabins must be small: no cabin in Mulfinger's book is larger than 1,200 square feet. The smallest is 210 square feet—still bigger than Fred Manfred's writing shack. Anything larger is a house or a lodge.

> A cabin must "respect the environment . . . enhance the landscape, not overpower it."

Mulfinger points out that to call a mansion a cabin is a misuse of the word. The word "cabin" comes first from middle English and "describes a small room on a ship [still the first meaning in modern dictionaries]." He quotes Viola's speech in Shakespeare's *Twelfth Night:* " 'Make me a willow cabine at your gate.' She refers to a tiny hut fashioned of twigs and boughs.

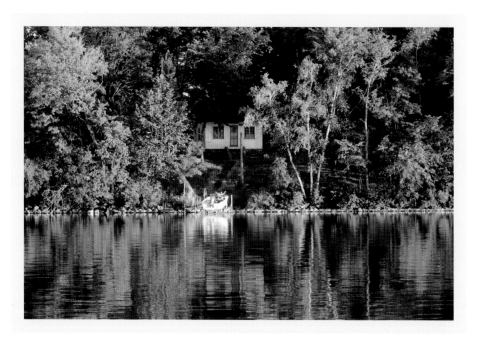

Today's cabins, more often than not, still fit that description." The other definitions go on: the pilots' cabin on an airplane, officers' cabins on a ship,

the sleeping cabin on a big truck, second-class accommodations on an ocean liner, and more. ("Cabin" can even be verbed: "They cabin in the woods on holidays," but I don't recommend it. "Verbing," that is; holidays are splendid. We need 150 of them a year!)

The cabin's linguistic history goes back past Middle English, to Old French, Old Prussian, Latin, "perhaps pre-Latin origins." Thoreau would have liked that speculation. So "cabin" is ancient in human history and consciousness, a word and an idea to honor and contemplate—preferably

ABOVE Green Lake, Wyanett Township, Isanti County

ABOVE Ice fishing houses before the busy season, on the shore of Mille Lacs

while staring out a window at what-
ever splendors nature provides
at the moment, listening to a chorus
of birds and lake water lapping.

While the fantastic price of mod-
ern real estate close to water will
exclude most of us from those pleas-
ures, there is one kind of cabin life
we can all enjoy for not much more
than Thoreau paid for Walden. It will
not be to everyone's taste, particu-
larly sunbathers. No one yet owns

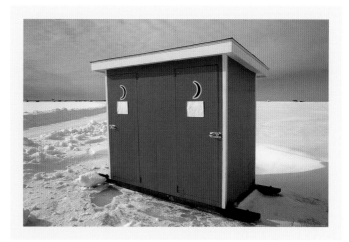

the ice that tops the lakes and rivers in late November or early December.
When the ice is sufficiently thick to be safe, great numbers of Minnesotans
truck fishing cabins onto the lakes—four inches of new clear ice to support
a person, five for a snowmobile, twelve to fifteen for a truck. How many of
us? In 2004, 147,000 ice house
licenses were sold—10,821 in
Hennepin County alone. Like
other cabins, some are simple,
even primitive—a stool, a hole

*When the ice is sufficiently thick
to be safe, great numbers of Minnesotans
truck fishing cabins onto the lakes . . .*

in the ice, a pint of peppermint schnapps, a small propane stove—and some
are elaborate, comfortable, even suburban in their splendor, with plasma
TVs, sound systems, wet bars, port-a-potties, plenty of heat, sleeping lofts.
I hope a few are equipped with guitars and flutes. Some lakes, like Mille Lacs
with its 5,000 ice houses, resemble small cities in the winter. The standard
size for a fish house—or cabin—seems to be ten-by-sixteen-feet, well within
Thoreau's spiritual and architectural ballpark. Dark houses are smaller,
maybe only five-by-five-feet. The fancier ones are painted bright colors,

ABOVE Portable "biffs" on Mille Lacs

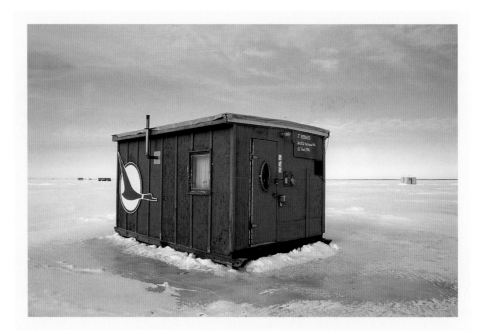

. . . four inches of new clear ice to support a person, five for a snowmobile, twelve to fifteen for a truck.

a little touch of gaity in a winter-white world. Your expenses consist only of what you choose to spend on your fish cabin, plus your license and fishing gear. Your temporary real estate will disappear in spring, and every year a few tardy fish house movers find themselves the owners of drowned cabins. Winter real estate, while cheap, is temporary, but then, considered from Thoreau's or the old Buddhist's perspective, what real estate isn't? Even a million-dollar hideaway on a popular lake will go the way of the ice, as indeed we will ourselves.

ABOVE Ice fishing house with the North Central Airlines logo, Mille Lacs

BELOW Ice fishing house, Mille Lacs

NEXT PAGE Cabin on Mille Lacs, Crow Wing County. Most anglers who migrate to Minnesota's lakes and rivers each May for the "Opener" are in search of the prized walleye. The current state record came in at 17 pounds, 8 ounces.

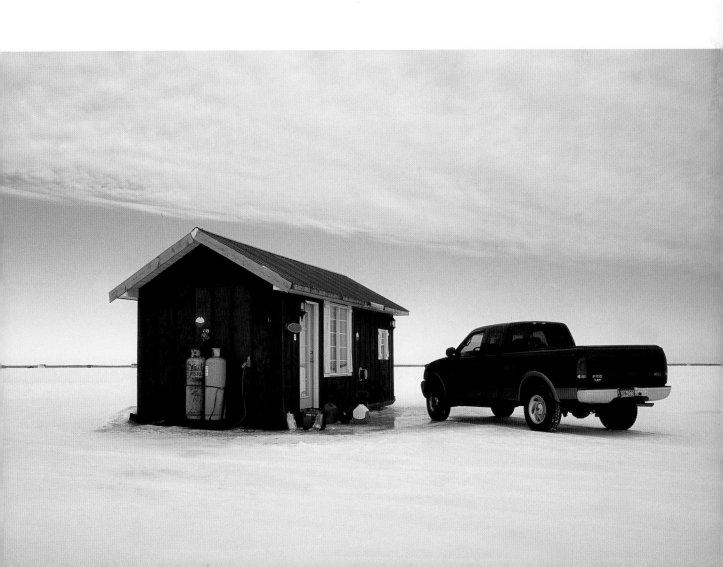

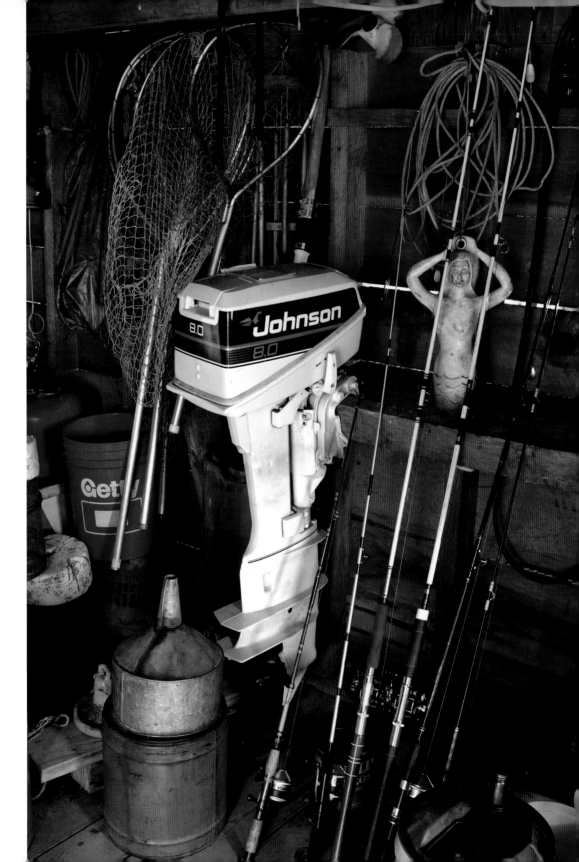

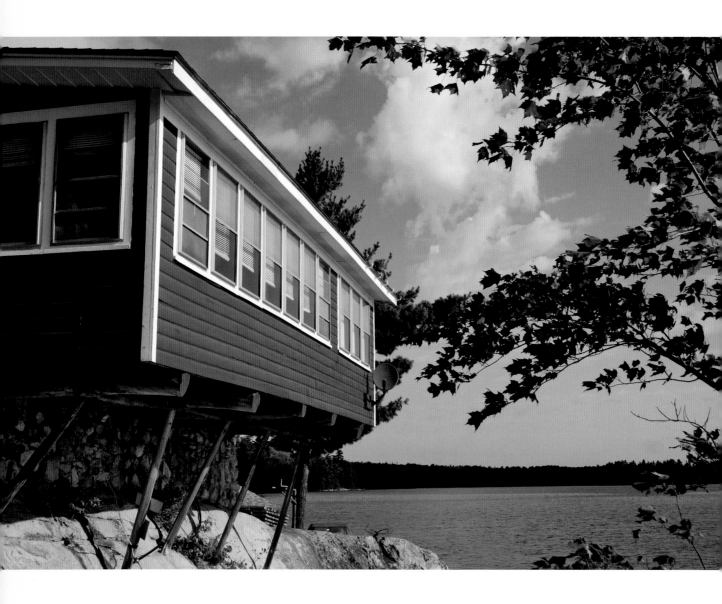

ABOVE Sand Point Lake, Voyageurs National Park, St. Louis County

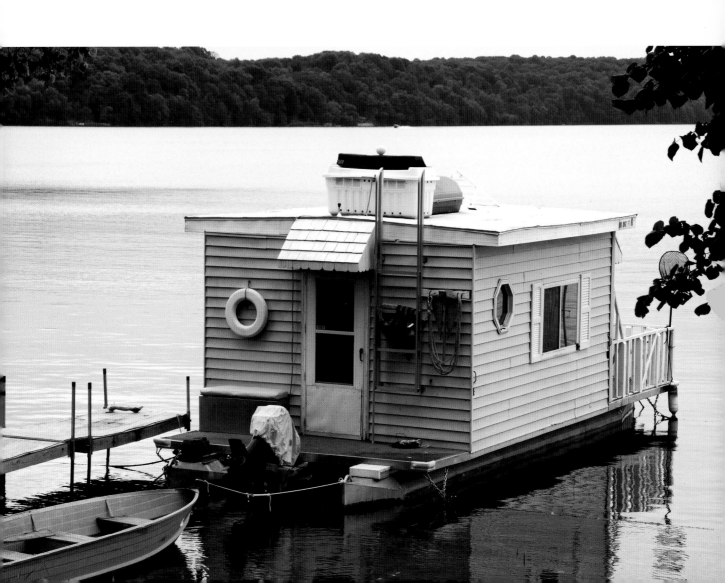

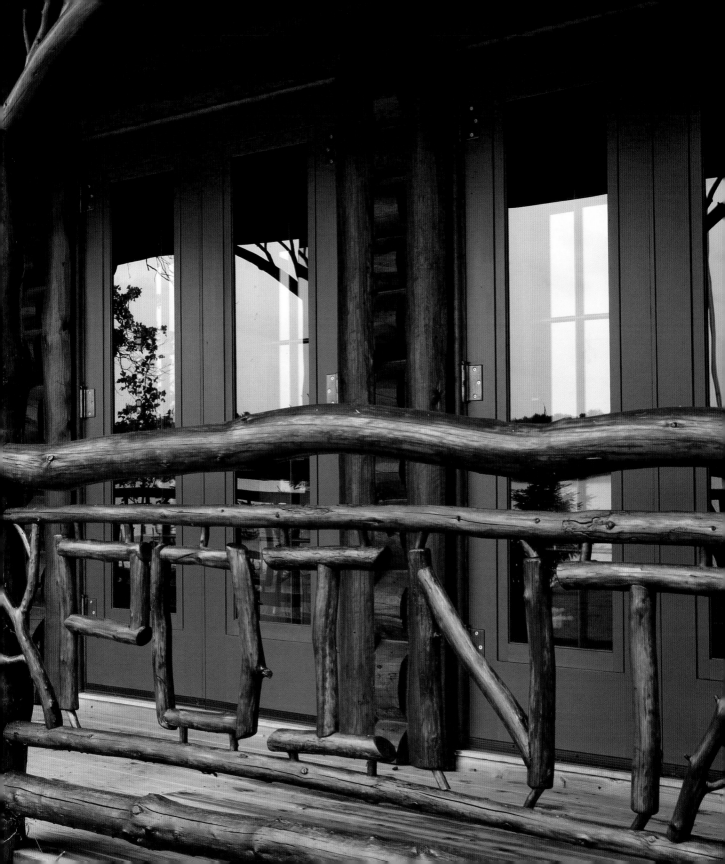

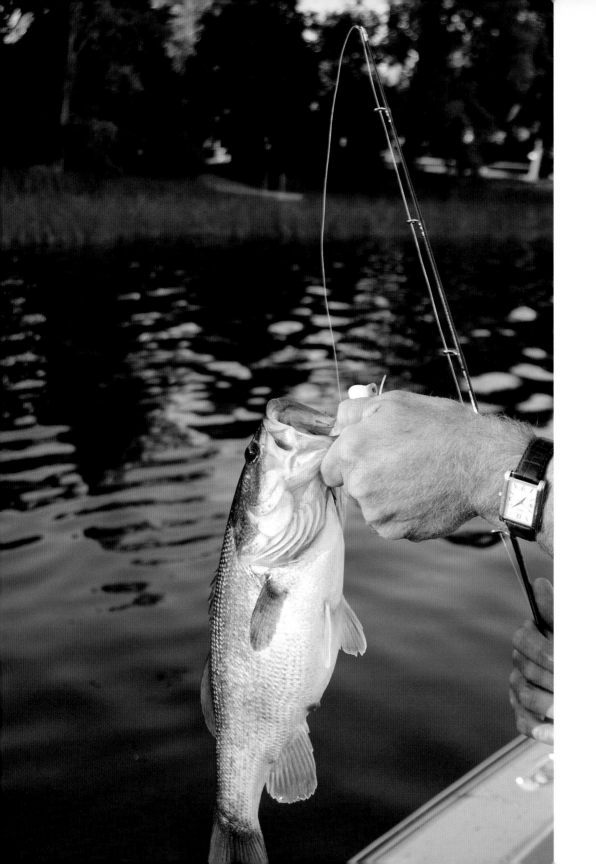

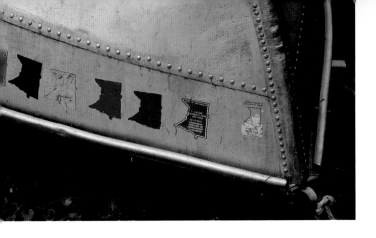

LEFT Largemouth bass caught on Lake Irene, Douglas County

5

Small cabins —

 and small islands with many cabins —

 are best loved in privacy and solitude

 (maybe with one or two particular others).

\mathcal{G}iven the meteorological facts, with month after month of blustering sub-zero winter (good for ice fishermen, torture for the normal . . .), three-day howling blizzards quickly followed by clouds of mosquitoes and biting flies, and months of enervating tropical humidity and temperatures punctuated by killer tornados, Minnesota can hardly be described as enjoying a blessed climate. Outdoors, more than anywhere else on the planet except Mongolia, central Siberia, the middle of Iceland, or Manitoba, is a place of threat and violence. Watch your back when you leave the house. Something out there means to kill—or at least maim—you.

Yet this unlikely, probably God-forsaken piece of the United States has been at heart a little lucky. Its difficulties, and distance from coasts, have saved large parts of it from thick settlement—in some places, any settlement at all. It is home for a big chunk of the last substantial wilderness on the continent: the Boundary Waters Canoe Area (BWCA), Voyageurs Park,

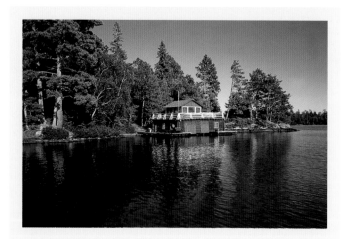

and Isle Royale. The country around Rainy Lake and Lake of the Woods, though much logged over for a century or more, is still large, harsh, and mysterious enough to give the illusion that you are the first to set foot on that ground in many places. When you fly over this section of the state in a small plane on a moonlit night, you see perhaps one lonesome narrow road threading its way through the dark woods, but a multitude of

PREVIOUS PAGES "Doc & Gram's" cabin on Spider Island (1916), Mille Lacs, Mille Lacs County

ABOVE Lake Vermilion boathouse, St. Louis County

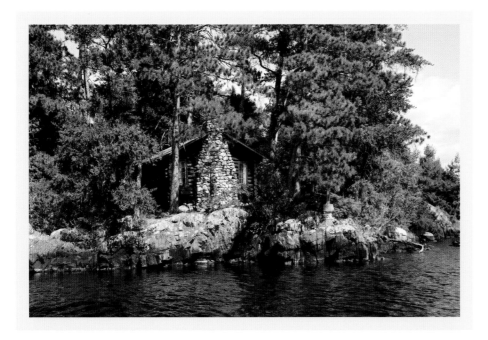

lakes, ponds, sloughs, marshes glittering in the moonlight. Water is more visible in the darkness than we are. In the dark spaces between the water live wolves, bears, moose, bobcats, deer, coyotes, more of them than of us, I hope. And cabins.

Minnesota has produced a rich "cabin literature," both practical and ruminative. I list only a few for your attention; there are many more. In the last generation fine books were written by Sigurd Olson, Calvin Rutstrom, Justine Kerfoot; more recently, by Douglas Wood, Susan Hauser, Paul Gruchow. One name that ought to be on this list isn't, because though his book was clearly *inside* him, he never finished it. Instead he lived it in his marvelous collection of cabins,

In the dark spaces between the water live wolves, bears, moose, bobcats, deer, coyotes, more of them than of us, I hope. And cabins.

ABOVE "Studio" cabin on Rainy Lake (1916), Koochiching County. The island "Atsokan" (Ojibwe for "storyteller") was first purchased for $500 from the Ojibwe by Ernest Oberholtzer and later sold to a man by the name of Major Roberts. Major Roberts built the cabin as an art studio for his daughter, who was an oil painter.

and left it to Joe Paddock, his skilled biographer, to tell his story in another book, *Keeper of the Wild: The Life of Ernest Oberholtzer.*

Ernest Carl Oberholtzer was born in Davenport, Iowa, in 1883, a modest-sized trading town on the Mississippi. He came from a family of bank clerks and (curiously enough!) real estate brokers. Ernest's only brother, Frank, born in 1882, died of a brain fever in 1890, after which Ernest's father summarily deserted the family. I doubt Ernest ever saw him again. That left him, seven years old, an only child to be raised by his mother Rosa and his German grandparents. Though obviously a Mama's boy (what choice did he have?) he seemed to have been a sturdy outdoorsy fellow until he was felled by rheumatic fever at seventeen. Doctors informed Rosa and Ernest that his life would likely be short, his heart weak, and his health always delicate. Bad news for a lively young fellow. After he recovered a bit, he went off to Harvard

94

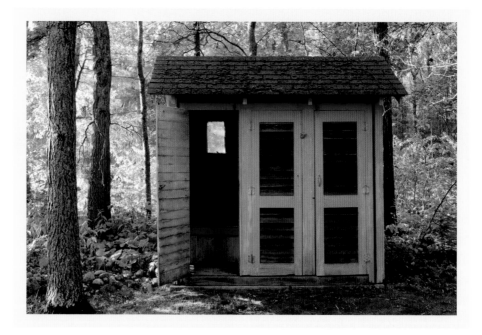

ABOVE A "two holer" with a supply closet between. Lake Belle Taine, Hubbard County

in 1903 to study landscape architecture in a department molded by Frederick Law Olmsted (the progenitor of Central Park and many another green space in urban America), and also to learn the violin and music theory. Rosa moved to Boston to be close enough to make sure that young Ernest was taking proper care of himself. To celebrate his graduation in 1907, he toured Europe in 1908 by bicycle with Conrad Aiken, his good friend and classmate, and later one of the distinguished poets of the century. Aiken, too, had a sad boyhood, having lost his parents to a murder and suicide in their house in Savannah, Georgia.

In 1909, probably thinking there was no point pursuing a hectic career if he was going to be shortly frail, then dead, he decided to indulge his childhood fantasy. He arrived in International Falls, Minnesota, a lumber town on the Rainy River at the Canadian border and frequently the coldest place on the North American continent. He bought a wood canoe, a pair of snowshoes, and (I hope!) a warm coat, then set about exploring this harsh wilderness. If this killed him fast, at least he'd have enjoyed himself a bit. He died at ninety-three in 1976 still in sound health, though senile. The brain gave up before the rheumatic fever–seasoned body.

He bought a wood canoe, a pair of snowshoes, and (I hope!) a warm coat, then set about exploring this harsh wilderness.

Over his long life Oberholtzer had many adventures and many passions.

ABOVE A man snowshoes near cabins on the Upper Cascade River, fifteen miles from Lake Superior, about 1950.

95

ABOVE Road to the cabin. Lake Ida, Douglas County

He explored the Rainy River drainage north through Manitoba to Hudson Bay with his Ojibwe friend and fellow explorer Billy Magee. He produced the first maps of the area. He learned the Ojibwe language, collected folklore and stories, and became a passionate (and very skilled) photographer, recording a primitive life now lost forever. He became a political activist, traveling, testifying, and writing endless essays and letters (but no book, alas . . .) to save the Rainy Lake and River wilderness from being dramatically changed by dams that would produce and sell electricity and denude the North of timber and animal life. After many years' work, he succeeded in the late thirties in halting this insane development. He deserves solid credit for the preservation of Voyageurs Park and the BWCA.

Oberholtzer was a kind of premature hippie, a well-educated Harvard man who refused to get a steady job, join the middle class, or to concern himself with making money. He lived, as the cliché has it, from hand to mouth, beholden to no one—though he never refused gifts. He seems to have taken every word of Thoreau to heart, pursuing his career as an inspector of snowstorms.

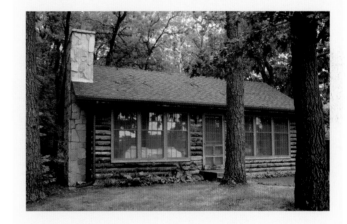

But it is his career as a builder and connoisseur of cabins that interests me here. Though he came of real estate–selling stock, Oberholtzer had no interest in owning anything that he couldn't carry with him in a pack or in a canoe. He slept in back rooms in winter—as renter or guest, depending on luck—and spent his summers, I presume, outdoors, canoeing and pitching a tent. He must already have started accumulating books, and he always traveled with his "everyday"

ABOVE Cabin built in 1950 on the southeast shore of Spectacle Lake, Wyanett Township, Isanti County

violin, but stashed his "Sunday" violin somewhere safe. He resembled Albert Einstein in this; the two were almost of an age, Einstein born in 1880. They both loved their violins and water: Oberholtzer a canoeist and Einstein a sailor. (You never know if you are on the water when you might need a line or two of a Mozart sonata or a Bach fugue. Keep the fiddle handy.)

You never know if you are on the water when you might need a line or two of a Mozart sonata or a Bach fugue.

Oberholtzer came into his real estate empire just after World War I. A local developer named Hapgood tried to start a "farm resort" on Deer Island in Rainy Lake. He hired Oberholtzer to assist him. When the scheme failed, Hapgood owed Oberholtzer seventy-five dollars, but in lieu of payment gave him the deed to three tiny islands among the hundreds in Rainy Lake. On county maps they were called the Review or Japanese Islands, but Oberholtzer rechristened his

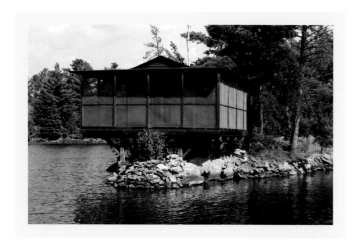

three skinny sardines of bare rock and scrub timber by their old Indian names: Hawk, Mallard, and Crow. In 1920, he began his impressive collection of cabins—eventually nine in all—on Mallard, the middle and smallest of the three. The island itself is 1,200 feet long and in places only 50 feet wide. The Hawk and Crow remained uninhabited—guardian islands. Narrow channels in the lake separated the three.

(1) First he built the "Japanese House," a little one-room pavilion with a veranda. It faces east, into the sunrise (the islands lie roughly on an east-west axis: sunrise to sunset, a metaphor for the day). The Japanese House

98

ABOVE Ernest Oberholtzer's "Japanese House" (1920), Rainy Lake, Koochiching County

in fact occupies its own separate rock connected to Mallard by a narrow footbridge. Kamo no Chōmei would have felt at home playing his *koto* there.

(2) Oberholtzer bought an old lumber camp cook boat, the *Wanigan,* and moved it to the north side of the middle of the island. There he pumped fresh water from the lake for drinking and washing, and there he cooked and entertained. Like Thoreau he was a competent cook and a hospitable host, famous among his many friends for his entertaining stories. An old brass school bell summoned guests to table. Recycling of used buildings to new ends is a fine cabin tradition.

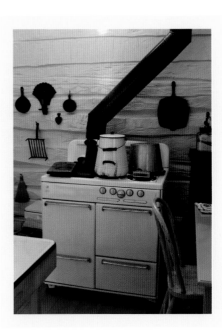

(3) He also bought an old floating brothel and gambling den that served the lumberjacks, who would pull up anchor and move quickly across the watery border whenever police arrived to cause trouble from either Canada or Minnesota. He moved it to his island, and called it Cedar Bark House, after its wood siding. It housed a battered upright piano, piles of music, several hundred books, a bed or two, and a pair of comfortable wicker rockers with reading lamps.

(4) He built a square, three-story "Bird House," tall enough to peek out just over the tree tops. Its dimensions are probably 10′ by 10′. The bottom story was filled with Oberholtzer's collections and artifacts, papers, notebooks, and glass plate negatives from his big Graphlex camera. The other two stories were libraries and guest bedrooms, a couple of thousand books jammed floor to ceiling in every available cranny. The stairs are steep as ship's ladders.

(5) Across from the *Wanigan,* he built a little two-story cabin he called the Cook's House. The bottom story, next to the lake, became an artist's studio because of its fine light. Many of Oberholtzer's friends came there to

ABOVE Cabin kitchen, Clearwater County

paint. When he left the island after his senility, his friend, the late Gene Monahan, a well-regarded portrait painter from Ranier, took it over as her summer studio. Her portraits of Oberholtzer, both middle-aged and old, are lovely and full of character. He seems, by the look of them, to have been half elf, half sage. He was a small, compact man.

(6) If you have sunrise at one end of your island, you need a west-end cabin, too. Oberholtzer called this the Front House. Its two stories housed a few thousand more of his growing book collection, beds for guests, and a front veranda to watch the sunset. I can testify that it is a fine place to listen to noisy loons and watch northern lights.

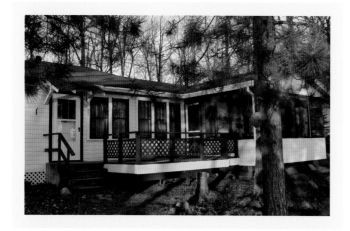

(7) He built a sturdy "Boat House" next to the *Wanigan,* but after his death it was remodeled as a "Book House," with more shelves to hold his unmanageably vast library. Thoreau, Kamo, and Po contented themselves with a few choice books in their cabins, but Oberholtzer was greedy—a biblioholic. He ordered books by the case from dealers all over the country, then barged them out from the local post office or train station. By the time he stopped being able to read them, probably the late '60s, fifteen thousand or so crowded every available space on the island, in closets, under stairways, under roof eaves. And such books! I found first editions of Thoreau, Mark Twain, Whitman, Hawthorne, rare books on arctic travel and exploration, scholarly linguistic tomes on Indian languages, a handsome first edition of

If you have sunrise at one end of your island, you need a west-end cabin, too.

ABOVE Pokegama Lake cabin, Bass Brook Township, Itasca County

ABOVE Ernest Oberholtzer's books and snowshoes

Edward Curtis's Indian photographs, and, of course, signed first editions of his friend Conrad Aiken's books. Mallard Island became one of the major private libraries in Minnesota, all gathered in by a man without a job or much income.

(8) In 1937 he sold his now-dead mother Rosa's house in Davenport and with the surplus money built the "Big House." The rest of his Lilliputian domain are clearly "cabins," but this might qualify as a genuine house. It is built into the highest hill on the island. Its three stories included another kitchen, a couple of roomy bedrooms with reading chairs, a small office with Oberholtzer's desk, and finally a large sitting room dominated by a big fire-

place and two odd hanging decorations: a beautiful handmade wood canoe and an antique Ojibwe sacred drum, a gift from Oberholtzer's Indian friends. In the middle of the room sits a seven-pedaled, vintage upright grand piano and piles of *very* good music: Mozart, Mendelssohn, Beethoven, Bach, even moderns like Debussy and Bartók! Oberholtzer's "Sunday" violin rested in its case next to the piano, waiting for the old ghost to come and bow a few tunes. His well-worn scores of Bach give evidence that he practiced regularly.

(9) Finally in 1950, he built a heated and insulated cabin, the "Winter House." It was warm, tight, practical, built to survive this ferocious winter, but aside from the usual crammed bookshelves, it's the most boring of them—less wind whistling through the eaves, fewer loon tunes, less lake water always lapping. Maybe this magical island was never meant as a home

ABOVE Inside Oberholtzer's library

for modern technology, only kerosene lamps, drafty fireplaces, and outdoor crappers (into a pail, not a pit), its only bathtub the lake on rare warm days.

Oberholtzer's Mallard Island is still there, of course, mostly intact as he left it. It's now administered by the foundation that bears his name. You can go there yourself if you have good reason to be there. It's been used by environmental groups, writers, composers, performing musicians, artists, scientists and by groups of Ober's old companions, the local Ojibwe. I've been there, loved every inch of it, disappeared into the library, made soup on his *Wanigan* stove and egg coffee in his white, church-basement coffeepot, practiced Beethoven, Haydn, and Bach in the middle of the night on both of the rickety pianos, watched dawn and sunset from both ends, fallen in love, and written romantic poetry on that island, but I shall probably not go again. Small cabins—and small islands with many cabins—are best loved in privacy and solitude (maybe with one or two particular others). I've had my

ABOVE One more sign of Ernest Oberholtzer's love for music, located in the "Cedar Bark House"

turn. Now it's yours if you want it. Besides, I'm seldom within five thousand miles of northern Minnesota in summer. More of that in a while.

Oberholtzer's islands and his cabins offer all the architectural charms a cabinologist could want. There's plenty of music (not to plug in but to play or sing), and a little something to read. Rainy Lake is still well stocked with fish—though you can't drink the water anymore without boiling. You can see into Canada from the Front House. Rainy Lake keeps meandering a long way into Ontario, island-studded all the way.

Long after Oberholtzer became senile, in 1973, the local Ojibwe and his numerous other friends and admirers brought him back to the island for a ceremony to install a bronze plaque on the crest of his little cabin kingdom. "Ernest Carl Oberholtzer: For Fifty Years a Friend of the Ojibwe and Defender of the Wilderness." I asked my friend Allan Snowball, whose grandfather, a shaman, was one of Ober's best friends, if he remembered being there for the ceremony and seeing the old man, then ninety. "His body was there, but his soul had already left." What a lovely, delicate way to put it! And it's true. Three years later, body and soul rejoined each other. Wherever they disappeared, I hope there are cozy cabins with music and a few books. When Thoreau was dying—a good deal younger than Oberholtzer—his sister Sophie asked him if he had made his peace with God. "I didn't know we'd quarreled," said Henry. Oberholtzer might have said the same. 🍃

> Wherever they disappeared,
> I hope there are cozy cabins
> with music and a few books.

ABOVE Pelican Lake, Mission Township, Crow Wing County

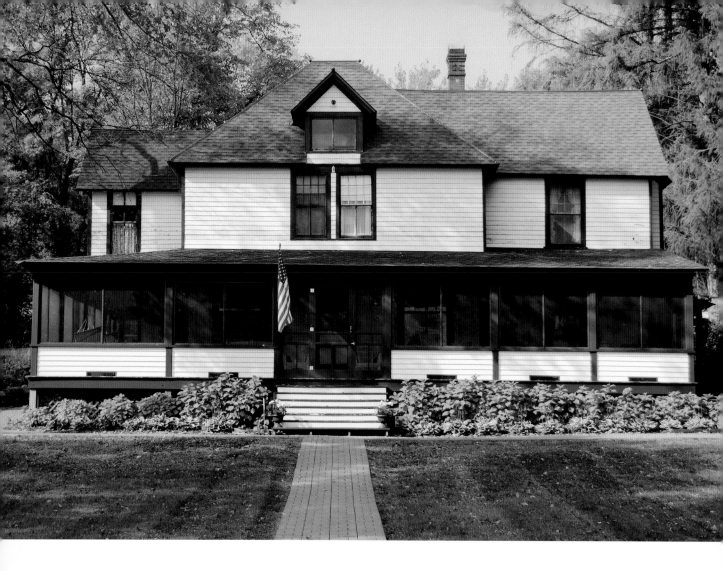

ABOVE The historic Thompson summer cottage, Lake Minnetonka, Hennepin County. In the fall of 1886, a prominent Minneapolis attorney, Charles Telford Thompson, purchased a lakefront lot on Lafayette Bay from the infamous James J. Hill. On his lot Charles designed his Queen Anne–style cottage and completed construction the following year, 1887. In 1998 the cottage was named to the National Register of Historic Places and today it serves as one of the last reminders of nineteenth-century cabin life on Lake Minnetonka.

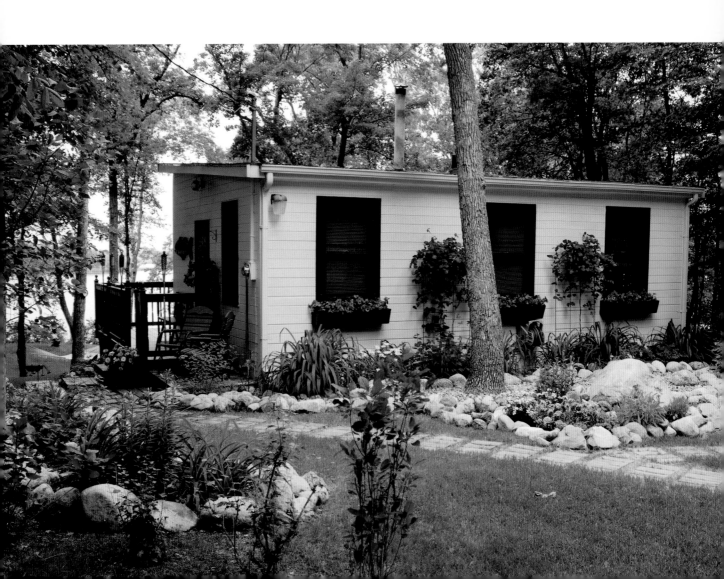

ABOVE Camp Friendship, located on the shores of Clearwater Lake, Wright County. Originally founded in 1964, Camp Friendship provides summer camping for more than 2,700 people with disabilities each year.

BELOW Fish Hook Lake cabin, Todd Township, Hubbard County

RIGHT Crescent moon outhouse, Rabbit Lake Township, Crow Wing County

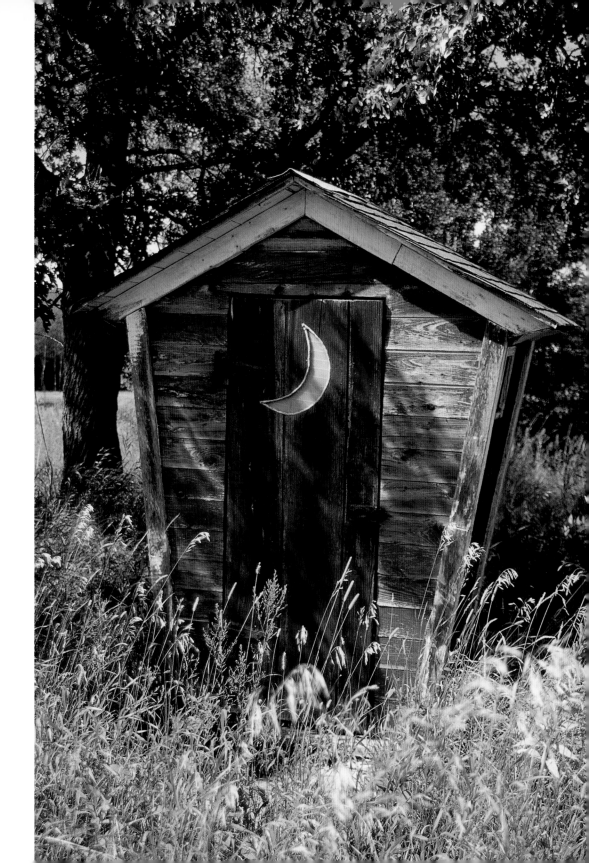

111

PREVIOUS PAGES AND ABOVE Bay Lake, Crow Wing County. The original cabin was built in 1933 using logs from Oregon.
The cabin sits on an acre of land, is virtually surrounded by water, and is accessed by way of a 300-foot, single-lane driveway.

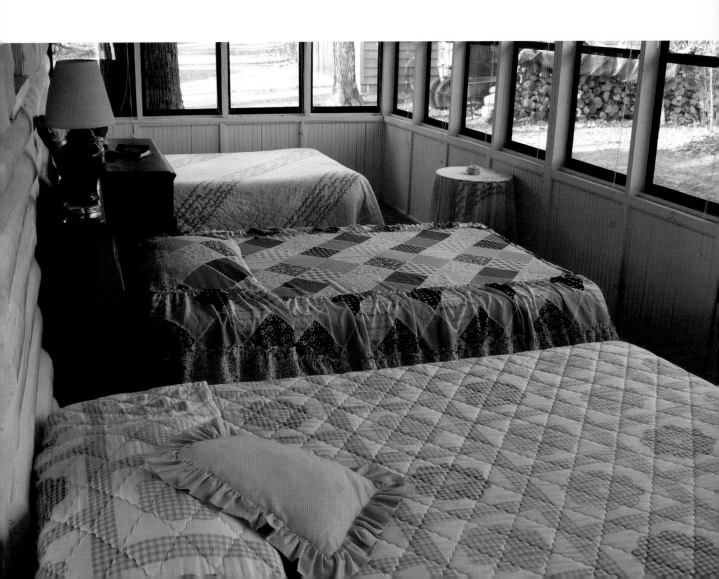

BELOW Pokegama Lake, Bass Brook Township, Itasca County. Sleeping on the porch and waking to the sounds of the loons is a Minnesota tradition.

6

Mind peaceful, body at rest,

this is where I belong.

Po Chü-i

*9*began this excursion into the universe of cabins many pages ago with a whimsical anecdote about my American students who couldn't imagine any joy in their ordinary daily life at forty—except at the cabin, the lake, the retreat, the *other* world. Their essays, I confessed, depressed me a little, so I never repeated the assignment. Now, dear reader, I have a darker confession to make. Those students are, in fact, me. I did not lie—or even exaggerate. Those students were real: they wrote those very essays, which were duly graded and returned in a properly professional manner (though probably a little late). The slight dissembling consisted of the fact that I agreed with them—and I was already well over forty, even fifty.

Real life—real joy—happened only at the cabin. The rest was *maya*—illusion.

Real life—real joy—happened only at the cabin. The rest was *maya*—illusion. So I'll give a little description of my cabin, and its history. I don't think I'll tell you *exactly* how to find it, but you might be able to anyway if you are clever and persistent.

From earliest boyhood, I have been an uncomfortable American, never feeling quite at home with the ideas, language, or attitudes around me. I was an odd duck, but then so are many citizens of this vast and various country. I mistrusted all "progress" not interior, and that sort was the most difficult to achieve. On the surface I was a plump, jolly, oversized fellow who sang and told jokes and scribbled small poems. I muddled my way through my adult life, putting a modest amount of bread on the table, seeing as much of the rest of the

116

PREVIOUS PAGES Sunrise on Wigwam Bay, Mille Lacs, Mille Lacs County

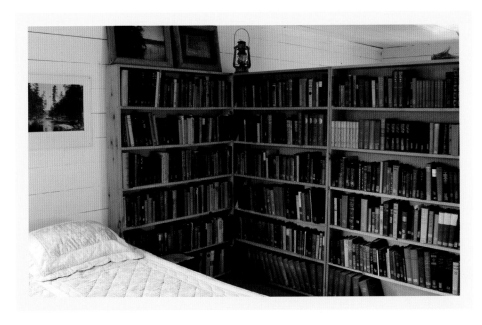

planet outside Minnesota as I could manage. But there was always a part of me that was elsewhere, a nagging sense that I still hadn't quite figured out where I belonged, where my feet felt comfortably planted on earth. I've found it now.

I'm sitting early in the morning of June 19, hunched over a wooden coffee table that holds this yellow legal pad, a few ballpoints, a green package of Polo peppermints, a bag of varicolored licorice, a tin of Skoal snoose pouches (wintergreen flavor), and a half-full coffee cup, probably now cold. There's a big, maybe five-foot-square window in front of the coffee table. When I am not scribbling I stare out at eight miles of saltwater—a fjord, though a wide, airy one. Across the water, a thirteen-mile-long, 3,500-foot mountain, Tindastoll, rears up steeply from the sea. Spring snow still lingers in the high saddles between the cliffs. I see the corner of a little fishing harbor, a breakwater of piled black stones, and a stack of maybe forty big plastic

ABOVE Ernest Oberholtzer's "Winter House," Rainy Lake, Koochiching County

yellow fish tubs waiting to be loaded with cod or haddock. Four or five small boats come and go all day. One just left. The sea is glassy and calm today, though it often is not. Good fishing. It is mostly silent in this little sitting room, only the ticking of a wind-up clock.

Outside, the sea sloshes peaceably, and a lively noisy river, the Hofsá, that drains a small glacier about ten miles up a long narrow valley into the mountains to the east, comes barging downhill into the fjord with its load of fresh water. The river mouth is right under my window, next to the harbor. I hear both water noises simultaneously. Out the window there's a gravel spit that varies in size depending on the tide. The water begins a hundred feet from my window. At water's edge there's a line-up of maybe thirty or forty eider ducks with young chicks. The drab brown eider hens are teaching the new chicks to fish, diving arse up into the fjord. The stately and beautiful black-and-white drakes oversee the family activities. Eider ducks are good quiet neighbors. A whimbrel, with its enormous curved beak, just flew by the window trilling. A few noisy terns dive for fish, making their triumphant machine-gun noises. An invisible golden plover, somewhere in earshot, just sounded its melancholy hoot. The thick grass below the window is studded with dandelions, buttercups, and what I refer to scientifically as "that pink flower." That's the view out my cabin window. I am, like Po Chü-i, in love with it—madly, ecstatically in love with it. I am a lucky man.

That's the view out my cabin window. I am, like Po Chii-i, in love with it— madly, ecstatically in love with it. I am a lucky man.

Unfortunately, my luck requires a long trip. I'm a saltwater man, not fresh. I prefer mountains, not crowding my back, but in sight. I'm no lover of trees, which seem to me only a means of hiding whatever it is in the world that is worth seeing. I loathe heat past 60°F and mosquitoes. Minnesota

118

may not have been exactly the right place for me to be born. But I was, and for better or worse, it is home. But when the trees leaf out and the insects arrive, I flee to my retreat. With luck, you do your best to flee to yours.

On June 19, today, we are two days from the solstice. At this latitude, about 66°, the sun doesn't even try to fool you by pretending to set, nor will it till August. This is the season of light. I've watched out this window for years now, and have never seen it twice the same. It's a little like living inside a kaleidoscope. I've also watched the dim winter light, and can assure you that no darkness is like any other darkness. Who needs movies or television when this is going on? Television now exists here, but until very recently the TV shut down for all of July and for every Thursday of the year. Who in their right mind would bother with TV? In July? Are you mad?

Who in their right mind would bother with TV? In July? Are you mad?

ABOVE Bay Lake, Crow Wing County

Have you guessed it yet, dear Reader? My cabin is on the north coast of Iceland, barely south of the Arctic Circle. The ocean out the window (according to the map) is the Arctic Ocean, but who cares what it's called? Saltwater is saltwater; it miscegenates as it pleases. The cabin has a name, as everything does in Iceland: Brimnes—the gravel spit peninsula. It is an exact description of the front yard. Like most such names in Iceland, it's a commonplace. There are probably fifty Brimneses in the country; one is a large working farm just south of town. Foreign travelers looking for me are sometimes confused. My Brimnes is in "town," an urban cabin (though not very urban). Hofsós (meaning the mouth of the Hof River) is an old Viking trading station, named on maps from the sixteenth century. Though it has declined since then, around two hundred of us still live here. It's enough.

Hofsós is, in fact, two almost separate towns invisible to each other. The "new" Hofsós—grocery store, gas pump, bank, post office, flag factory, muffler factory, garage, bar and café, church, mostly recent concrete houses, straight orderly streets (two or three of them), right angles—occupies the top of the small bluff overlooking the sea. Down a short steep gravel road going into the little canyon formed by the river's mouth is the fishing harbor and the "old" Hofsós: maybe fifteen tiny houses, no two remotely alike in either structure or color, sit helter-skelter at every conceivable weird angle to one another going up and down the steep grassy hillside. These cottages are now mostly used in summer, getaway cabins for stressed out Reykjavíkurs. Twenty years ago, they were all falling into ruin—leaking storage sheds for fish nets, motors, old junk. They had all once been houses of the working poor—a group that included most Icelanders not very far back in their history.

Brimnes is just the right size for two Americans, or only one when one of them is writing a book. A small sitting room (with two glorious huge windows), a small shotgun kitchen—with counters about three feet high! (The Americans who live here are 6'5" and 6'. A lot of bending . . .) A miniscule

ABOVE Ten Mile Lake, Shingobee Township, Cass County. Tubing has come a long way in the past few years from old truck and tractor tubes to today's fancy inflatables. "Don't forget to keep the tube stem down!"

back bedroom, and a decent size "master" bedroom, made large by knocking out the wall between two tiny bedrooms, plus an unfinished, dirt-floored basement about five and a half feet high, home for a clothesline, a washing machine, and a ghost.

I met a man in his sixties who had lived in Brimnes as a boy: eight children, mamma and papa, and aged grandma. Where did they put them? You probably don't want eleven relatives together in your tiny getaway cabin. Remember they wintered here too, huddled and bunched in the little rooms against the fierce cold. It makes one just a bit thankful for the surplus room gained by joining the middle class.

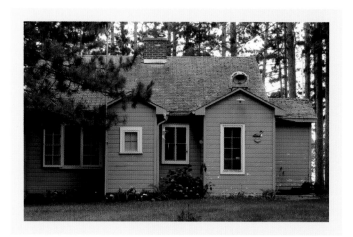

Many locals, a decade or two ago, wanted to simply bulldoze the old shacks. They didn't "look nice." A local carpenter and farmer, Valgeir Þorvaldsson, had fallen in love (as one does) with his home countryside and decided to put some energy and labor into saving this charming and lovely old ghost of a town. He re-carpentered and re-roofed Brimnes, throwing out the rotten fish nets. Marcy and I fell in love with this magical little house. One night Valgeir came over to sit up late in the pink light, drinking a little cognac and *aquavit,* speculating on the meaning of things. I bemoaned the fact that I was probably too broke to buy a house here in Hofsós where I'd fallen so precipitously in love with landscape, nature, culture, light, neighbors. "Maybe it is possible," said Valgeir; we drank a little more, shook hands, and by morning I had bought Brimnes. That was one of the two smart things I have ever done in my life.

ABOVE **Norway Lake, Cass County**

122

So now I sit looking out the window of Brimnes on June 19. While I have been scribbling, the sky has darkened and clouded over, and a small rain has begun falling. By day's end, it will likely clear and turn pink again. Whatever stunts the weather performs are all right with me.

To clear my head while I scribble, I go to the piano in the other end of the sitting room. It's a small Yamaha upright, nothing fancy, but serviceable and tuned. During the course of this essay, I've learned Bach's Partita in E Minor #6. It's an extraordinary piece, wildly dissonant—not only for the eighteenth century but for the twenty-first. Bach does not age or date. No real music does. (Nor do real cabins, if there is life inside them.) The Sarabande in that Partita is the saddest two pages of music I have ever played. When Bach finished writing it, he must have guffawed with delight. "Now that, by God, is *sad,*" the old German might have said to himself, a little proud. Art is mysterious. If not, it's commerce. I think of that Partita as correct "cabin" music. You might prefer country western. But remember the cabin "rule": play it yourself; don't let electricity do it for you.

Brimnes is a properly equipped cabin: it has a musical instrument, a few hundred books, local paintings and photographs on the walls (all gifts), a stove, a coffeepot, a bed, a table with chairs and stools, a couple of good reading chairs, and lamps to read by (for winter and a few dark summer days). Friends drop by—often musicians—and we have little concerts

for each other, a mezzo-soprano, a coloratura, a cellist, a flute, ten extra fingers for four-handed Schubert, and sometimes Valgeir's brother Þórhallur brings his accordian. He is a skilled player of dance music and sentimental old Icelandic songs. Fishermen sometimes bring fresh delights, maybe cod or steinbítur from the sea, or pink arctic char from the river. We cook together and toast the benevolent universe. If we could summon them from the other world, Henry Thoreau, Po Chü-i, Kamo no Chōmei, and even Yeats would feel at home in Brimnes.

After the fish and the wine and the music comes poetry. Cabin poems! The host demands. Jim Harrison and Ted Kooser sit in one corner.

Clear summer dawn,
first sun streams moisture
redly off the cabin roof,
a cold fire. Passing raven
eyeballs it with a quack.

Says Kooser. Not bad, says Harrison, and proceeds:

At the cabin I left the canola bottle open
and eleven mice drowned in this oil bath.
I had invented the mouse atom bomb.

Let's have another!

At my cabin
to write a poem
is to throw an egg across
the narrow river into the trees.

Yours or mine? Harrison and Kooser look at each other, shrug. Well, this one is mine, says Robert Bly, rising to his feet:

My shack has two rooms; I use one.
The lamplight falls on my chair and table,
And I fly into one of my own poems—
I can't tell you where—
As if I appeared where I am now,
In a wet field, snow falling.

But on June 19, the field is wet with a hard rain now, not snow. And I have the feeling that I have flown into the life of this cabin, Brimnes, a timber, metal-sided poem on the far edge of calm, kindly, cold, beautiful Iceland. I join Po Chü-i in this line from one of his poems about his thatched hall: "Mind peaceful, body at rest, this is where I belong." Yes indeed, Mr. Po.

125

Photographer's Note

I can hardly believe that this is the fifth book in the Minnesota Byways series! Early in the project, I came across an old postcard from the twenties written by a young woman who was spending her summer at a cabin on Clearwater Lake, near Annandale. At the end of her short message, she writes, "Having the time of my life." This phrase describes my feelings about photographing our state's cabins as well.

Writer Bill Holm and I approached the subject of cabins from different perspectives. Bill's writings take us around the world and back. He explores the cabin getaways from different traditions and cultures and also gives us a wonderful glimpse of his own cabin retreat on the remote north coast of Iceland.

As the photographer, my goal was to not only show cabins that speak to the long-held traditions here in Minnesota, but also to highlight unique cabins that clearly reveal their owners' personalities and whims, to illustrate cabin structure and design where very few rules apply.

The cabin is one of our treasured places where we go to relax, breathe fresh air, recreate, sleep, watch nature—oh, did I mention relax? As I traveled the state photographing cabins, I also participated in these cabin experiences, as if I were on a long cabin vacation myself. After a hard day on lake country back roads, I would pull over at a public access and throw in a line

ABOVE Bill Holm at Brimnes

for awhile. On overnight trips, I would take my coffee out to the dock to watch the sunrise. I hated to see it end.

Reflecting back, one of my most memorable experiences was on the back bays of Voyageurs National Park with Kevin Sheffer, U.S. park ranger. I will also never forget the time I spent on Mallard Island, on Rainy Lake, experiencing up close the cabin legacy of Ernest Oberholtzer. On other Minnesota lakes I was treated to boat rides by generous folks so I could capture those great perspectives from the water that would have been impossible from the road. I was even told about the best fishing holes as long as I promised to keep them to myself.

I am thankful to the many cabin owners who called and wrote me notes and letters about their special retreats. The response was so overwhelming that I found it impossible to see them all. I hope my photography gives a good representation of cabin life in Minnesota and helps each reader recall his or her own cabin experiences. A big thanks goes to the staff at the Minnesota Historical Society Press—especially my editor Pamela McClanahan— for giving me this yearlong vacation. Lastly, without the loving support of my wife Krin and children Emily and Matthew, "having the time of my life" would not have been possible.

DOUG OHMAN
New Hope, Minnesota

ABOVE **Doug Ohman**

NEXT PAGE **German Lake, Elysian Township, Le Sueur County**

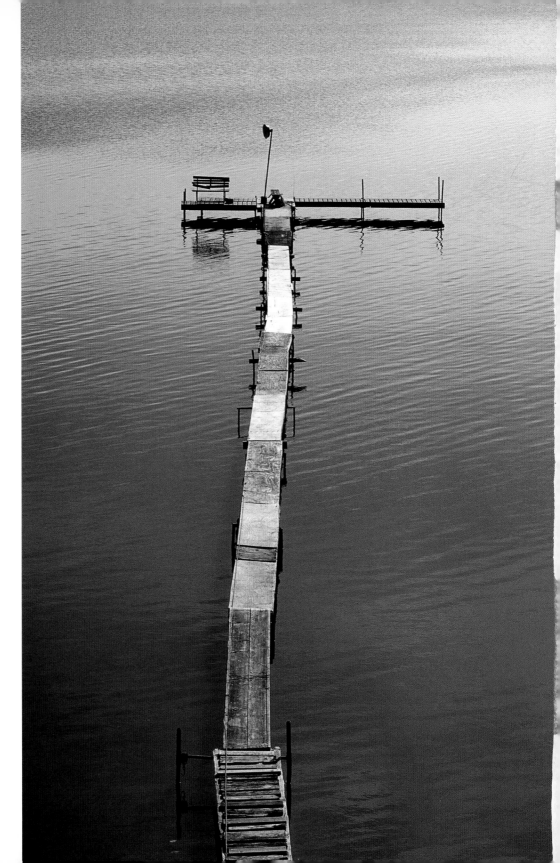